FUTURE AMERICAN PRESIDENT

50 STATES ★ 100 FAMILIES ★ INFINITE DREAMS

Matthew Jordan Smith

Published by Goff Books. An Imprint of ORO Editions

Publisher
Gordon Goff
www.goffbooks.com
info@goffbooks.com

Book Design
The Merryall Studio
www.merryallstudio.com

Editors
Haley Steinhardt
Soul Tree Publications
Allison Smith

Production Assistance
Meghan Wright-Martin

Project Coordinator
Matthew Ricke

10 9 8 7 6 5 4 3 2 1 First Edition

Library of Congress data available upon request.
World Rights: Available

ISBN: 978-1-939621-14-6

Color Separations and Printing: ORO Group Ltd.
Printed in China.

International Distribution: www.goffbooks.com/distribution

COVER PHOTO SUBJECTS: SKYE & NICOLAS

For Jayden,
with all my love

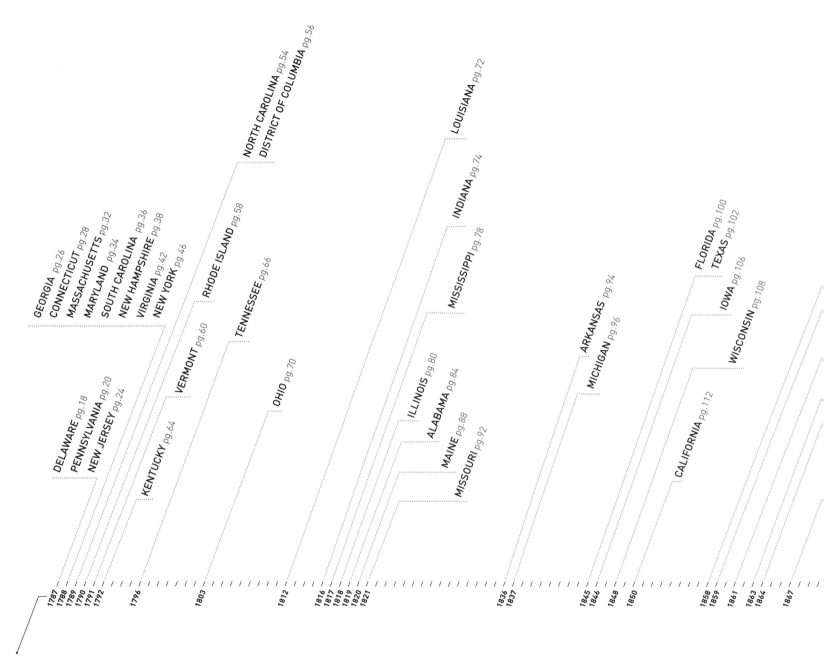

1787
1788
1789
1790
1791
1792
1796
1803
1812
1816
1817
1818
1819
1820
1821
1836
1837
1845
1846
1848
1850
1858
1859
1861
1863
1864
1867

STATE BY STATEHOOD
SHOWN CHRONOLOGICALLY

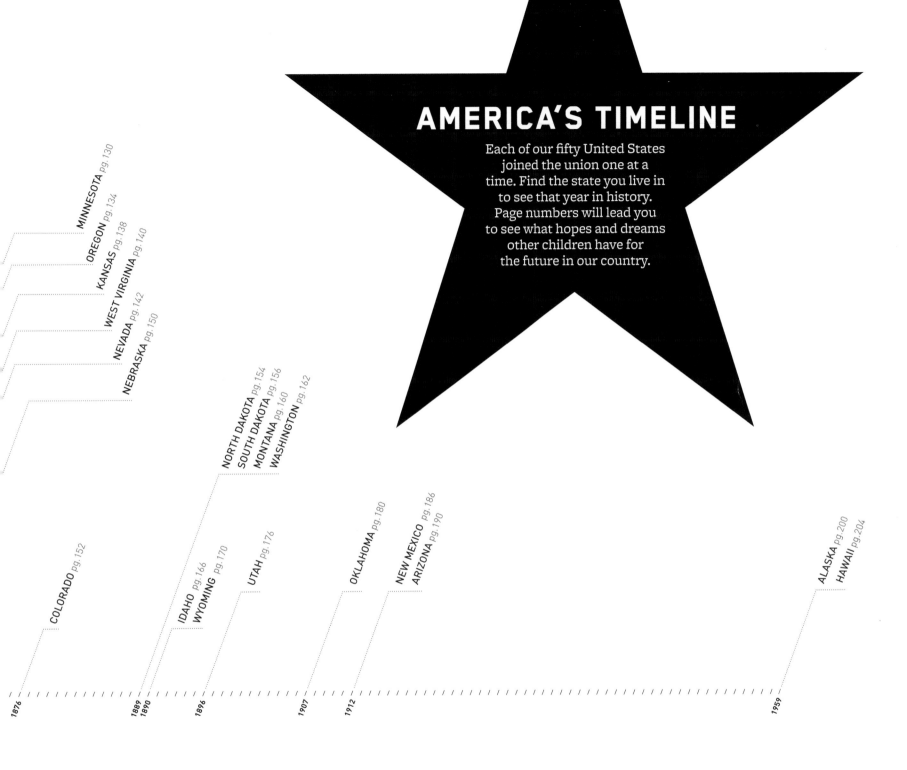

AMERICA'S TIMELINE

Each of our fifty United States joined the union one at a time. Find the state you live in to see that year in history. Page numbers will lead you to see what hopes and dreams other children have for the future in our country.

1876 1889 1890 1896 1907 1912 1959

Tell the truth.
Keep the peace.
Accommodate changing times
but cling to unchanging principles.
–Jimmy Carter

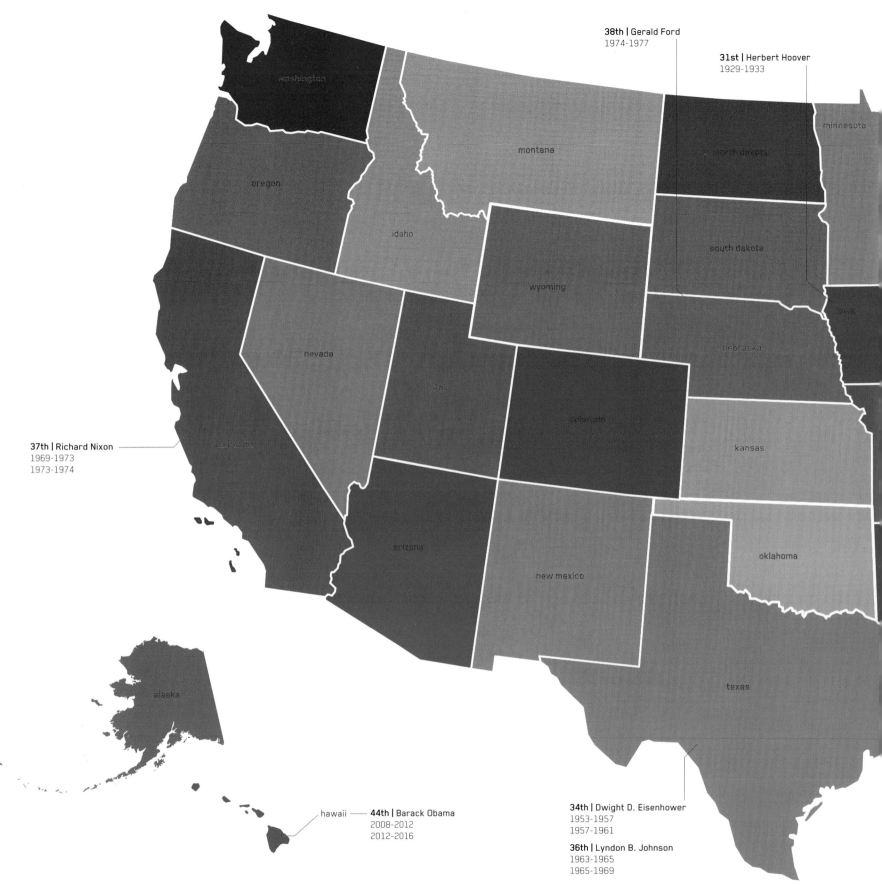

38th | Gerald Ford
1974-1977

31st | Herbert Hoover
1929-1933

minnesota

washington

montana

north dakota

oregon

idaho

south dakota

wyoming

iowa

nevada

utah

colorado

nebraska

37th | Richard Nixon
1969-1973
1973-1974

california

kansas

arizona

new mexico

oklahoma

alaska

texas

hawaii — **44th | Barack Obama**
2008-2012
2012-2016

34th | Dwight D. Eisenhower
1953-1957
1957-1961

36th | Lyndon B. Johnson
1963-1965
1965-1969

10

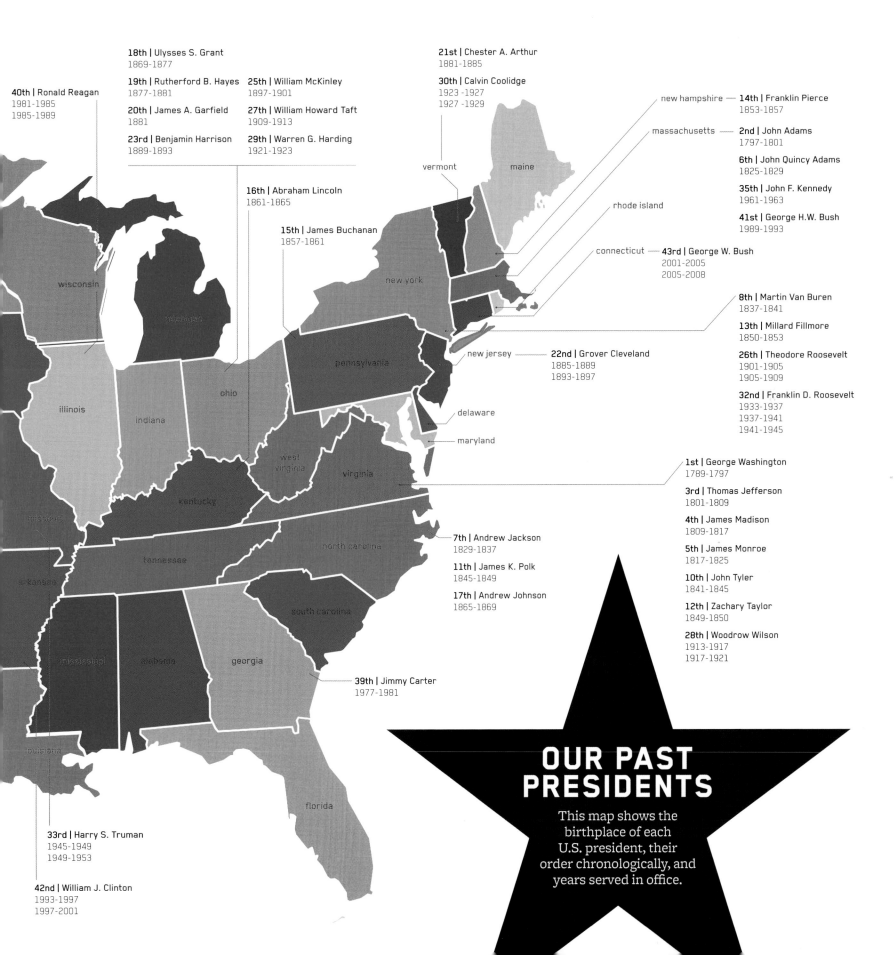

40th | Ronald Reagan
1981-1985
1985-1989

18th | Ulysses S. Grant
1869-1877

19th | Rutherford B. Hayes
1877-1881

20th | James A. Garfield
1881

23rd | Benjamin Harrison
1889-1893

25th | William McKinley
1897-1901

27th | William Howard Taft
1909-1913

29th | Warren G. Harding
1921-1923

21st | Chester A. Arthur
1881-1885

30th | Calvin Coolidge
1923 -1927
1927 -1929

new hampshire — **14th | Franklin Pierce**
1853-1857

massachusetts — **2nd | John Adams**
1797-1801

6th | John Quincy Adams
1825-1829

35th | John F. Kennedy
1961-1963

41st | George H.W. Bush
1989-1993

rhode island

connecticut — **43rd | George W. Bush**
2001-2005
2005-2008

16th | Abraham Lincoln
1861-1865

15th | James Buchanan
1857-1861

vermont

maine

new york

8th | Martin Van Buren
1837-1841

13th | Millard Fillmore
1850-1853

26th | Theodore Roosevelt
1901-1905
1905-1909

wisconsin

pennsylvania

new jersey — **22nd | Grover Cleveland**
1885-1889
1893-1897

32nd | Franklin D. Roosevelt
1933-1937
1937-1941
1941-1945

illinois

indiana

ohio

delaware

maryland

west virginia

virginia

1st | George Washington
1789-1797

3rd | Thomas Jefferson
1801-1809

4th | James Madison
1809-1817

5th | James Monroe
1817-1825

10th | John Tyler
1841-1845

12th | Zachary Taylor
1849-1850

28th | Woodrow Wilson
1913-1917
1917-1921

kentucky

missouri

tennessee

north carolina

7th | Andrew Jackson
1829-1837

11th | James K. Polk
1845-1849

17th | Andrew Johnson
1865-1869

arkansas

south carolina

mississippi

alabama

georgia

39th | Jimmy Carter
1977-1981

louisiana

florida

33rd | Harry S. Truman
1945-1949
1949-1953

42nd | William J. Clinton
1993-1997
1997-2001

OUR PAST PRESIDENTS

This map shows the birthplace of each U.S. president, their order chronologically, and years served in office.

AS A CHILD, I DREAMED OF BECOMING A PHOTOGRAPHER FROM THE TIME MY FATHER GAVE ME MY FIRST CAMERA.

Those dreams became more tangible after seeing a photographer who looked like me living his dream. Seeing someone who resembled people in my community achieving my definition of success was a powerful moment of focus and inspiration. From that moment on, I knew that I could be exactly who I wanted to be. I then turned my dreams into my reality through hard work, dedication, and determination.

Today, the influence of my role models has inspired me to write my third book, *Future American President*. I want everyone to know, especially our youth, it's OK to dream and to dream big. My project is about believing; believing your child has the ability to become a future President of the United States. I know, this sounds ambitious, right? It is! Somewhere, right now, a child is dreaming of becoming someone important when they grow up, just like I was when I got my first camera. How do we motivate that dreaming child to turn their hopes into reality? We have to show them that kids just like them can grow up to change the world. *Future American President* is an inspirational tool made for children that shares the dreams and goals of young people all across the United States.

This project started in mid-2008 when I was working on a book project called *Joy 44*, a follow up to my first two books, *Sepia Dreams* and *Lost and Found*. In *Joy 44*, a small section featured three children as future presidents. One of those children was my stepson, Jayden, who is half Japanese. I took Jayden to a park and photographed him wearing a beautiful red, black, and blue Japanese Yukata. He held a sign that read, "Mr. Future President 2052." During our shoot, I noticed something I'd never seen before – a crowd of parents gathered around to watch, smile, and comment. Some even asked where I would be using the photograph. The project stalled with the economy in 2008, but the impact on Jayden was profound. We hung the image on his wall and from time to time, I'd catch him looking at it, or he'd ask, "How old was I in this picture?" The photograph still hangs in his room today.

In early 2012, I received a call from my client and good friend, Kayla Lindquist at Sony. Lindquist asked me if I could photograph images based around the 2012 election year for an exhibit that Sony sponsored in New York City. As I thought about the exhibit theme, my mind drifted back to the Joy 44 project and a suggestion my wife made about the special "Kids as Future Presidents" subsection. The next thing I knew, I was planning the first steps for what would become *Future American President*.

Defining moments in our childhood help shape our adulthood. The day I photographed little Jayden in 2008 was critical for the both of us. That day, I discovered the impact a powerful image has on the subject, their parents, and the people in their lives. As I wrote out my thoughts for my new project, I kept the vision of that day in mind. I knew I wanted to have each child holding a sign, like the original picture of Jayden, that pertained to becoming a future president, but this time I wanted to add their own handwritten statements when possible. The sign my stepson held in 2008 was more than just a sign – it was an idea. An idea that I hope will resonate with every child and every family in the United States. The simple idea is filled with unlimited possibilities. Ideas of what can be, not what is. *Future American President* is a project devoted to creating defining moments and empowering children to dream bigger.

The hardest step to take is usually the first. I knew it was important to get to work right away, even though I had no idea how I could afford to travel to all 50 states. Thank God my wife is adventurous, and that she loves to drive and

travel, because we packed up all my Sony camera gear and Profoto lighting equipment and hit the road. My idea was to find families with young children and photograph the children in a manner that would inspire and empower them for decades to come.

You might think finding children to photograph was easy; it was far from that. Before we set out on the first trip, I had to ask myself: "What would make me say yes to a stranger who wanted to photograph my family?" I would want to know the person was sincere and that they were capable of doing what they described. To demonstrate my abilities to the parents of potential subjects, I brought along my first two books, *Sepia Dreams*, my book on 50 African-American celebrities describing how they made their dreams come true, and *Lost and Found*, my second book, sponsored by Microsoft and endorsed by the National Center for Missing and Exploited Children. In most cases, my books were the perfect icebreakers to start conversations. Still, asking strangers if you can photograph their children for a book is no easy task, and we had our share of setbacks. I quickly learned the best approach was to ask this simple question: "Do you think your child could ever become the President of the United States?"

Nothing good in life ever comes easy, and creating *Future American President* proved this in more ways than one. My first road trip was one of my biggest lessons. I knew of a great location for a photo shoot and thought it would be a wonderful place for the first image. The location was seven hours away by car, so my wife and I got up early, around 3:00 am, and started the drive to Death Valley. When we arrived, we quickly learned that our timing was off. It was too early for families to start traveling because the school year was still in session. After several hours without seeing any families with small children from the United States, we knew we had to rethink the plan. We would only be able to travel when children were out of school. We would have to squeeze in all of our travel during the summer months. We made it through the first year and covered 22 states before running out of money for travel.

When you really want something, the universe will always test you to see how badly you want it. My test came during the winter of 2012 – 2013, when those voices of doubt started to creep in and question whether or not photographing children in every state was possible. With more than half of the United States left to visit, and little capital to work with, it seemed like an uphill battle to complete the project. Then, I started receiving signs that the impossible was possible. While flying to Seattle, Washington, I sat beside a gentleman named Dan Horn and shared my project with him, which was something I had never done before. This chance encounter on a plane lead to former President Jimmy Carter sending me a handwritten statement made exclusively for *Future American President*. Mike Kahn and Rosie Sandoval from Sony introduced me to JR Kenny from the Boys and Girls Clubs of America, who helped me connect with children across the United States, and Ted Fujimoto, founder and chairman of the Right to Succeed Foundation, offered his help and resources.

A parent told me about Kickstarter, a crowdfunding website, and we decided to launch a campaign to raise the needed capital to complete the project, but then things really got hard. The Kickstarter campaign was going badly and looked like it was going to fail. Then a good friend, Darryl Havens, called and gave me some of the best advice I have ever received. That advice led to exceeding our goal on Kickstarter. Without Darryl's advice, this project would never have come to life. Others also came to my aid to make sure this project did not fail. People like Eunice and Rev. Jordan Smith, David Vaskevitch, Skip Cohen, Samuel L. Jackson, Scott Bourne, Courtney B. Vance, Boris Kodjoe, Jesse Collins, Scott Sillers, William Hammond, Kayla Lindquist, Dr. Leslie N. Pollard, Ron Pollard, Kara Jacinta Mateo, Mike Carney, Mike Freze, Terri McMillian, and all the parents and Kickstarter supporters. When you fully believe in your dreams, the universe conspires to help you.

Future American President is for you. Female or male, rich or poor, black, white, Hispanic, multi-ethnic, Native American, Asian, or Inuit, this book is created to acknowledge your inner greatness. As you read this book, remember that I believe in you, and that I believe you have amazing potential. It is my dream that *Future American President* can serve as a catalyst to create defining moments that become a brighter future, and to help you push toward one goal… GREATNESS. Always dream big!

–Matthew Jordan Smith

"If there is anyone out there who still doubts that **America is a place where all things are possible,** who still wonders if the dream of our founders is alive in our time, who still questions the power of our democracy, tonight is your answer. ... It's the answer spoken by **young and old, rich and poor, Democrat and Republican, black, white, Asian, Hispanic, Native American, gay, straight, disabled and not disabled.**" When I heard from Matthew that he wanted me to write this foreword, I was more than thrilled. This very moment flashed in my head and I thought, "If those words from President Obama inspired so many people, then there's no reason why we can't do the same. If just one young person leaves these pages with that same feeling I

still have, then our mission is accomplished." On the night of November 5, 2008, President Barack Obama spoke these very words during his victory speech in Chicago, IL. On that night, his words did something more powerful than ever thought possible...they gave millions of dreams their wings. I know this because I experienced it first hand, sitting in my living room with big starry eyes, staring at the TV. I could tell something was different. What 12-year old attentively listens to anything, much less politics? It was like his words were fuel and with every word he spoke that little spark in me grew to a ferocious wild fire...I was invincible. It was in those moments I truly realized anything is possible, if you believe in a dream. I never want to loose this feeling.

> ...as young people, our dreams are judged as less valid or brushed off as insignificant. **Childhood is key.** At this time there's nothing but uncorrupted minds and non-biased opinions.

The future of this world lies in our hands, those sticky little marker-stained hands. Naturally, as young people, our dreams are judged as less valid or brushed off as insignificant. Childhood is key. At this time there's nothing but uncorrupted minds and non-biased opinions. Anything is possible until Doubting-Thomases convince us otherwise. As long as we are surrounded by positivity, then the opposition we face every day, that negative voice saying "no" and "can not" will become a beautiful and clear "yes" and "can."

The arts have always been my true passion, but my dream is to use that talent as a megaphone to bring to life those "yeses" and "cans." I hope that it will reach the ears of every young person just like me. Growing up, I was inspired by the performers and television shows I watched as a child: Michael Jackson and Beyonce; "That's so Raven" and

"Hannah Montana." Seeing artist with my complexion starting to pursue dreams at a young age fueled me to start pursuing my own dreams. I felt like I was looking into a mirror of my own future. I felt a connection, and sometimes I would cry, thinking "Why am I not up there? If they can do it, so can I." My experience led me to think about all the kids out there with my same dreams. Who do they see like them? Who do they have to look to and motivate them? The only way to properly nurture the huge dreams of these children is to give them that mirror and allow them to see these endless possibilities for their future, because who's to say that child won't be our future president?

As of 2010, the population of the USA was 308,745,538; 50.8% of them women, 49.2% of them men; 63% Caucasian, 16% Latino, 12% African American, 4% Asian, .7% Native American, .2% Pacific Islander, 1.9% two or more races, .2% other races; 46,215,956 below the poverty line; 104,853,555 under the age of 24. With so many different kinds of people sharing these 50 states we call home, it's up to us to display each and every one in a positive light. A young girl in New York, who has little money but a lot of potential, should have a strong, intelligent female to look to so she can say "She's just like me, and look what she's done!" A young African American boy in California should have a strong, intelligent, African American individual such as President Barack Obama to look up to so he can say," He's just like me, and look what he's done!" They should never doubt themselves when it comes to their aspirations and goals because they will have grown up with proof that it can be done, no matter whom you may be.

In this book, Matthew Jordan Smith has captured the beautiful and inspirational dreams of children. It shows the exact written words of these children, explaining what they would want to do when they are president. The writing may be barely legible, sweet baby chicken scratches, but the dreams and messages are perfectly spelled out. While reading through these letters I often thought, "Why didn't I think of that?" So, to all the grown-ups out there, prepare to be schooled by the kids this time. With each page you turn, your inspiration will grow. Join us in the creation of a beautiful future.

—ZENDAYA

DELAWARE

Daniel, 2

ANNIE JUMP CANNON
Astronomer Annie Jump Cannon was born in Dover, DE on December 11, 1863. She pioneered a classification system for the stellar phenomena she observed, and that system is still used today. She was also the first woman to become an officer of the American Astronomical Society.

PAUL GOLDSCHMIDT
Baseball player Paul Goldschmidt was born in Wilmington, DE on September 10, 1987. He is a multi-year MLB All-Star game player who was first drafted into the major leagues at age 23.

HENRY HEIMLICH
Renowned doctor and World War II veteran Henry Heimlich was born in Wilmington, DE on February 3, 1920. He is known throughout the world medical community for creating simple, innovative techniques to solve troublesome health issues. Most notably, he created the life-saving Heimlich Maneuver to help those who fall victim to choking.

FROM THE FIRST STATE
TO THE OVAL OFFICE
FUTURE PRESIDENT

FROM THE FARM
TO THE WHITE HOUSE
FUTURE PRESIDENT

PENNSYLVANIA

McKenzie, 6
Kacie, 5

LOUISA MAY ALCOTT
Novelist Louisa May Alcott
was born in Germantown,
PA on November 29, 1832.
She published more than
30, including her most well-
known work, *Little Women*.

GUION BLUFORD, JR.
Born in Philadelphia, PA on
November 22, 1942, Guion
Bluford is a retired NASA
astronaut and was the first
African American to travel
to space. In his time as an
astronaut, he logged more
than 688 hours of space
travel.

If I was President
I would help farmers
out more.
Farmers Feed
America!

McKenzie
Kacie

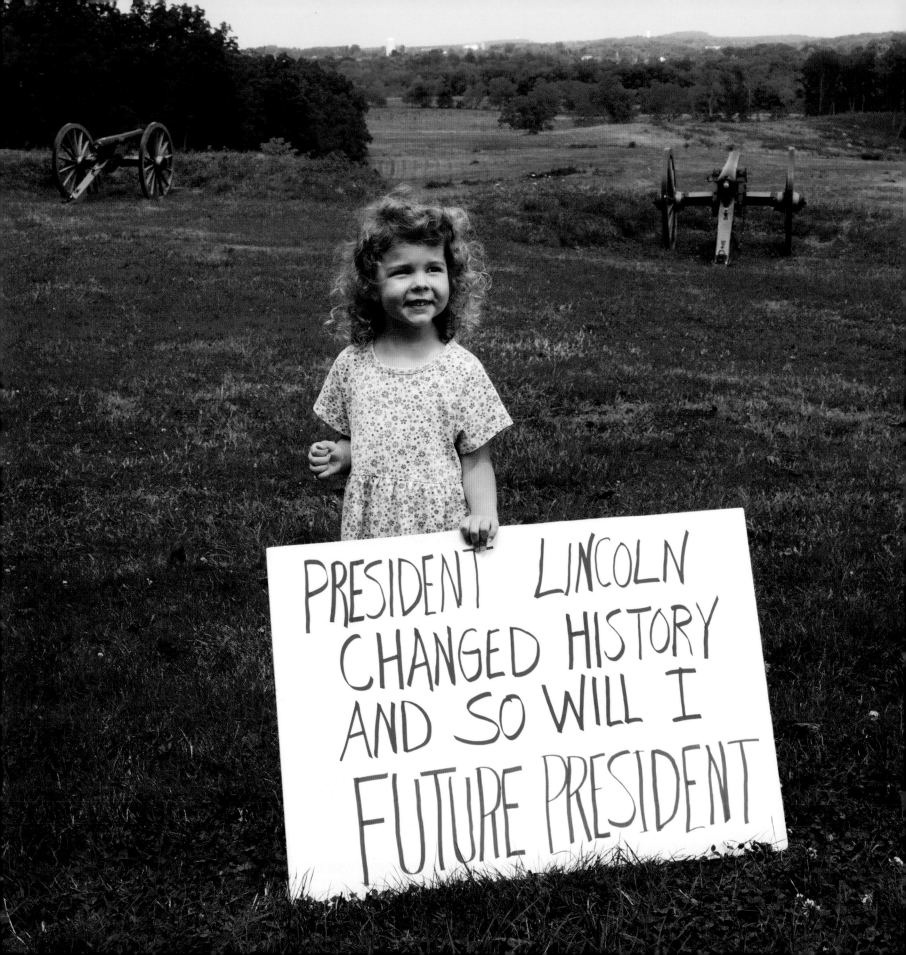

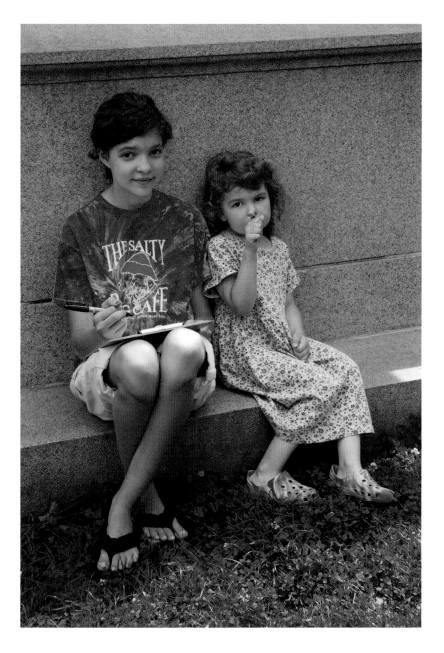

Moira, 13
Riona, 4

MILTON HERSHEY
The great confectioner Milton Hershey was born in Derry Township, PA on September 13, 1857. He created the Hershey Chocolate Company after deciding on a whim to try coating his caramels with chocolate. He also founded a school for orphan boys, known today as the Milton Hershey School.

If my younger sister were president, I would like the world to have a better economy.
Moira

Riona

William, 7

MICHAEL CHANG
Tennis player Michael Chang was born in Hoboken, NJ on February 22, 1972. At the age of 17, he was the youngest player ever to become the French Open / Grand Slam Champion.

ZOE SALDANA
Actress Zoe Saldana, who is known for her riveting performances in films such as *Avatar*, *Star Trek: Into Darkness*, and *Pirates of the Caribbean: The Curse of the Black Pearl*, was born in Passaic, NJ on June 19, 1978. She started her career doing dance and theater before appearing on the big screen.

BRUCE SPRINGSTEEN
On September 23, 1949 in Long Branch, NJ, famed bluesy rock n' roll singer and guitar player Bruce Springsteen was born. He is known for his rousing, anthemic songs that often tell the stories of small-town life.

For Future presindent
I would like nobody to smoke!

William

FUTURE
PRESIDENT
2036

GEORGIA

Noelle, 12

REBECCA LATIMER FELTON
Rebecca Latimer Felton was born in Decatur, GA on June 10, 1835. A women's rights activist at the time women first earned the right to vote in the United States, she famously participated in a political stunt that made her the first woman to serve in the United States Senate, though it was only for a single day. Her efforts took on significant and symbolic importance for the women's movement in our country.

DEFOREST KELLEY
Famously known for his role as "Bones," ship's doctor in the original *Star Trek* TV and film series, DeForest Kelley was born in Toccoa, GA on January 20, 1920.

MARTIN LUTHER KING, JR.
Civil rights leader, pastor, and humanitarian activist Martin Luther King, Jr. was born in Atlanta, GA on January 15, 1929. Thanks to his leadership, civil rights activists all over the United States were able to affect lasting change to our country's laws through peaceful demonstration.

If I were president I would change the voting age from 18 to 16 years old, because I feel by then (by the year of 2036), a 16 year old will be able to make more responsible ~~desi~~ decisions like being able to vote.

Noelle

BETSEY JOHNSON
Born on August 10, 1942 in Wethersfield, CT, fashion designer Betsey Johnson first emerged onto the scene during the "Youthquake" movement in the 1960s. Her styles really took off in the 1970s when she brought elements of the new wave/punk underground scene in London to her designs. Today, she has more than 60 clothing stores worldwide.

JOEY LOGANO
Racecar driver Joey Logano was born in Middletown, CT on May 24, 1990. At the age of 18, he won the Meijer 300 at the Kentucky Speedway. The following year, he was named the Sprint Cup Series Rookie of the Year.

I WIll GIVE EVERYBODY WhO IS hUNGRY POPCORN AND ICE CReAm naTaIIa SofIa

VOY.aDAR TODOSQUE TIENENhama PALOMITasy Re hELa DOS.

FUTURE
PRESIDENTIAL
SISTERS

Maggie, 5
Olivia, 7

ANNIE LEIBOVITZ
Annie Leibovitz is an American portrait photographer who was born in Waterbury, CT on October 2, 1949. She got her start at *Rolling Stone* magazine, and later photographed for *Vanity Fair*. She now exhibits her work in galleries and museums around the world.

If I was president I would give people food and money if they didn't have any.
MAggie!

If I were president I would help protect endangered Animals.
Olivia

PROTECT US NOW
AND
WE WILL PROTECT YOU
WHEN WE ARE PRESIDENT

Ethan, 9

W.E.B. DU BOIS
William Edward Burghardt Du Bois was born on February 23, 1868 in Great Barrington, MA. He was a civil rights activist for all people of color, a professor, and an author as well as a Harvard graduate, where he became the first African American to earn a doctorate degree. Du Bois was also one of the co-founders of the NAACP.

EMERIL LAGASSE
World-famous chef Emeril Lagasse was born in Fall River, MA on October 15, 1959. He has hosted cooking shows, owns several restaurants, and founded the Emeril Lagasse Foundation to help inspire and support disadvantaged youth.

DR. SEUSS
Theodor Seuss Geisel, known by millions all around the world as "Dr. Seuss," was born on March 2, 1904 in Springfield, MA. He is the author and illustrator of 44 children's books, including *The Cat In the Hat*, *Green Eggs and Ham*, and *How the Grinch Stole Christmas*.

If I was presiden I would lower house costs.

如果我是总统我要降低房价。

Ethan

MY ROAD TO
THE PRESIDENCY
STARTS HERE

OUR DAUGHTER
IS THE FUTURE
PRESIDENT

MARYLAND

Nora, 8 months

MICHAEL PHELPS
American Olympic swim-
mer Michael Phelps was
born in Towson, MD on
June 30, 1985. As of this
writing, he has earned 22
Olympic medals in swim-
ming, more than any other
athlete ever to compete in
the Olympics in any sport.

BABE RUTH
George Herman "Babe"
Ruth, Jr. was born in Bal-
timore, MD on February 6,
1895. Considered by many
to be the greatest player
in Major League baseball
history, Babe Ruth broke
record after record for
home runs, including his
last record of 60 homeruns
that remained unbroken for
34 years.

HARRIET TUBMAN
Harriet Tubman was born
into slavery sometime in
1819 or 1820 in Dorchester
County, MD. She escaped in
1849 through the "Un-
derground Railroad," a
name given for the route
from safe house to safe
house for escaped slaves.
She then became one of
the movement's biggest
heroes, being dubbed "the
Moses of her people."

SOUTH CAROLINA

Lyric, 11

JAMES MARK BALDWIN
Born in Columbia, SC on January 12, 1861, James Mark Baldwin was one of America's earliest influential psychologists, exploring the relationship between human evolution and psychology.

AZIZ ANSARI
Comedian and actor Aziz Ansari was born in Columbia, SC on February 23, 1983. In addition to his internationally known stand-up comedy tours, many people know him for his hilarious role on the TV show *Parks and Recreation*.

DIZZY GILLESPIE
John Birks "Dizzy" Gillespie was born on October 21, 1917 in Cheraw, SC. He was a performer and composer, and is known as one of the greatest jazz trumpeters of all time. He is also credited with creating the musical style known as "bebop."

I would make sure every kid, parent, and the elderly were equal no matter what color skin they are. Let him or her be honest and responsible to everybody they met.

Lyric

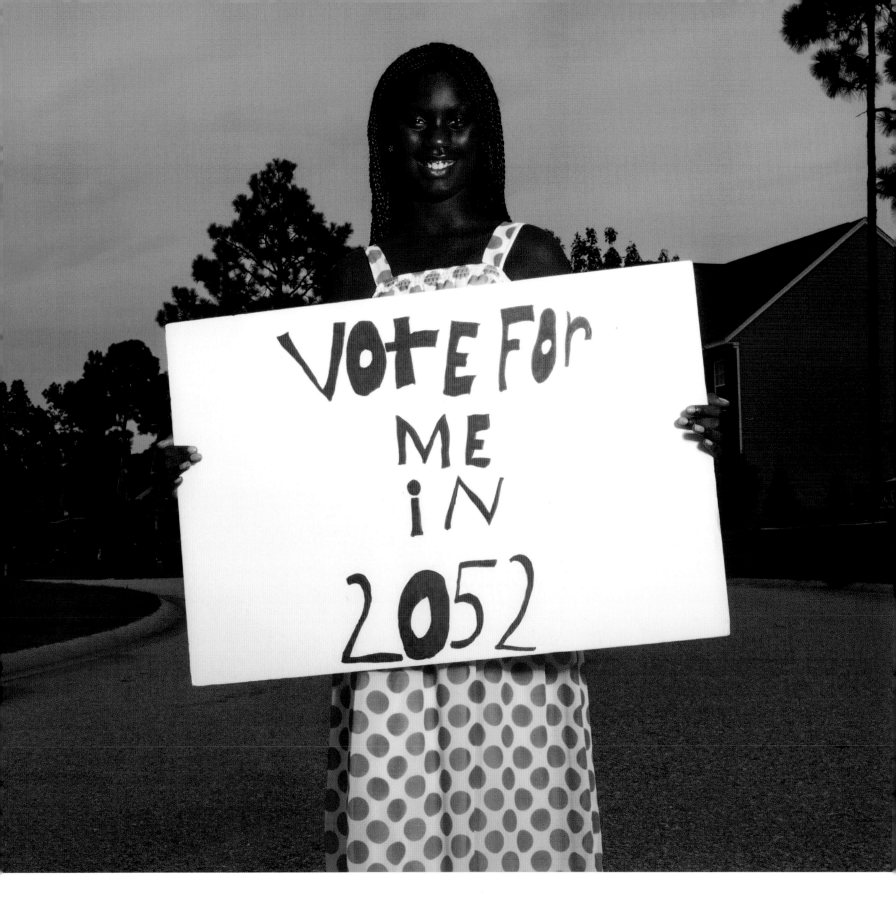

NEW HAMPSHIRE

Bree, 10
Brynne, 9

HORACE GREELEY
Horace Greeley was born on February 3, 1811 in Amherst, NH. He was the founder of both *The New Yorker* magazine and the *New York Tribune* newspaper. He was also an active supporter of women's rights and putting an end to slavery.

HANNAH KEARNEY
Olympic skiing champion Hannah Kearney was born in Hanover, NH on February 26, 1986. She began skiing competitively at only nine years old. Hannah then went on to win a gold medal in women's moguls in the 2010 Winter Games and a bronze medal in 2014.

If I were the president of the United States, I would help those who are poor and don't have enough money for their needs like food, water, and clothes. I would also make sure that all kids have a good education for their jobs they wish to have in their future.

Bree

If I were President of the United States I would make sure that everyone had equaly rights and opportunities.

Brynne

NEW HAMPSHIRE'S
PRESIDENTIAL PRIMARY

Since 1920, New Hampshire has held its presidential primary election before any other state. Changes in New Hampshire law in 1949 made the primary a direct selection of presidential aspirants, not a mere choice of delegates pledged to specific nominees. Held in February or March, during the week preceding any similar election elsewhere, the New Hampshire primary has become a critical first step on the road to the White House. Taking their responsibility seriously, New Hampshire voters test contenders during the months leading to the primary and have usually favored the candidate who ultimately attains the Oval Office.

MY FIRST PRESIDENTIAL PRIMARY

WILL TAKE PLACE HERE

Mr. Future President

NEW HAMPSHIRE

Landon, 5

ALAN B. SHEPARD, JR.
Alan Shepard was born on
November 18, 1923 in East
Derry, NH. He was the first
American ever to travel to
space as well as the Pres-
ident of the Mercury Seven
Foundation, which offers
merit-based college scholar-
ships for science students.

If I were President,
I would...
Protect our Oceans and
all the animals and fish
especially the Sharks.

LANDON

Diego, 6
On vacation from Texas

WILL YUN LEE
Actor Will Yun Lee was born in Arlington, VA on March 22, 1971. He is best known for his roles on hit TV series such as *True Blood*, *Bionic Woman*, and *Fallen*, as well as in the film *The Wolverine*.

I would say to the crowd Girl stuff can be for boys and boy stuff can be for Girls. Diego

VIRGINIA

Nick, 12
Brandon, 10

MATOAKA "POCAHONTAS"
Matoaka, affectionately
known as "Pocahontas"
(meaning "playful"), was
born into the Powhatan tribe
in the area now known as
Virginia around 1596. She
is best known for being a
peacemaker. She worked to
befriend and protect the En-
glish settlers who first came
to the Americas, eventually
marrying Jamestown colonist
John Rolfe.

GEORGE WASHINGTON
First President of the United
States, George Washington
was born in Westmoreland
County, VA on February 22,
1732. He led the Continental
army in the fight against the
British during the American
Revolution.

If I was President I would grant more money to the goverment so they can. Build more Ball fields.

Nick
Brandon

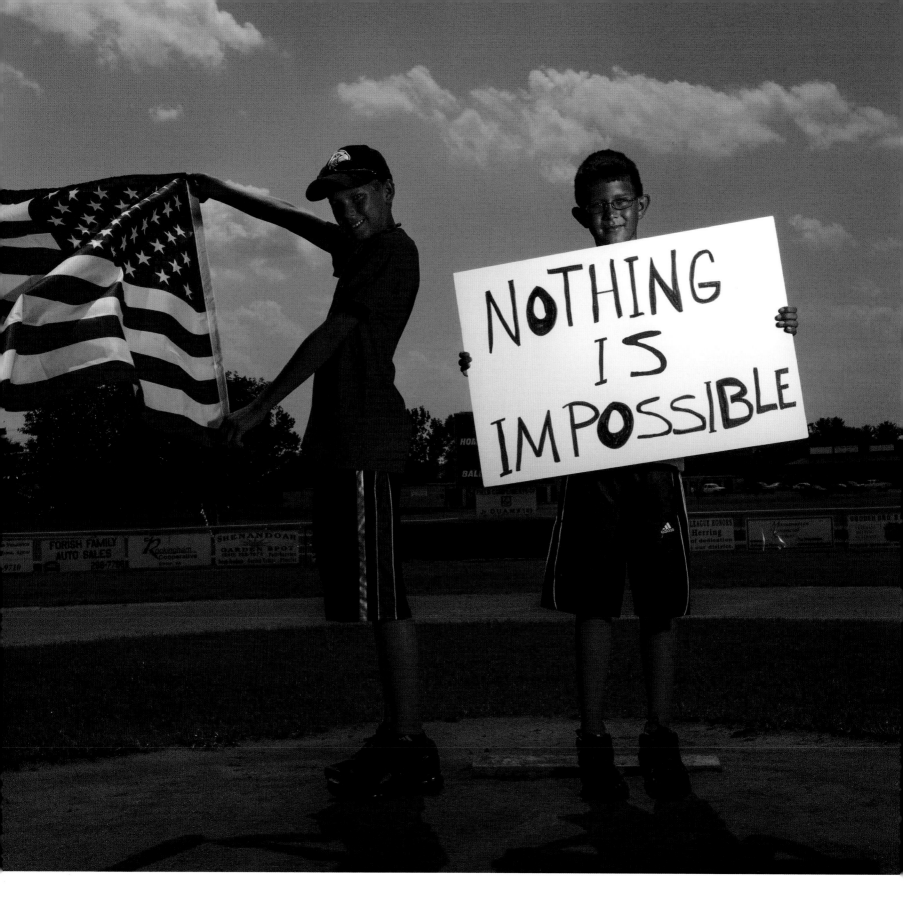

I MAY DROOL NOW BUT MY GOALS ARE ENDLESS FUTURE PRESIDENT

NEW YORK

Hunter, 4 months

WHEN HUNTER RUNS
FOR PRESIDENT HE WILL
SELECT THE SMARTEST
PERSON FOR HIS RUNNING
MATE AND SHE WILL HELP
HIM MAKE THE WORLD BETTER
FOR FUTURE GENERATIONS.

Manny, 10

If I was president there will be no ~~fasis~~ racism, And people to be safe.

Manny

JIMMY FALLON
On September 19, 1974, Jimmy Fallon was born in Brooklyn, NY. He is an actor and comedian best known for his work on *Saturday Night Live* and more recently, as host of his own talk show, *Late Night with Jimmy Fallon*. Fallon has also appeared in a variety of other television programs and films.

I WOULD LET eveRRONE waLKDOGs

savannah

If I were president, I would connect ▨ Canada and Mexico together with the United States as The United States of North America.

Rocco

The sign held by the family reads:

PARENTS OF A FUTURE
UNITED STATES
PRESIDENT

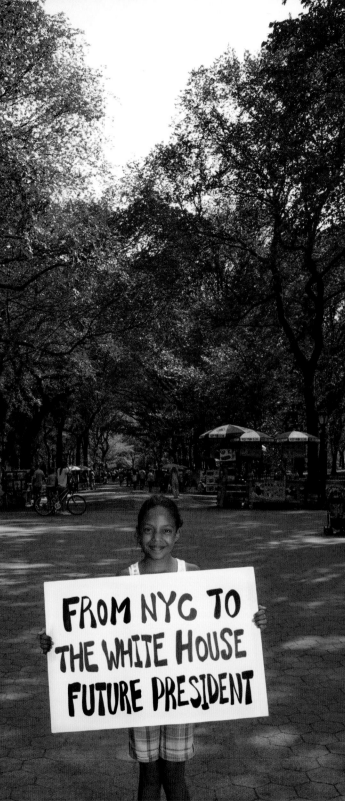

NEW YORK

Izabel, 10

LUCY LIU
Actress Lucy Liu was born in Queens in New York City, NY on December 2, 1968. She is best known for quirky role on the hit TV series *Ally McBeal*, as well as for a variety of other TV and film performances, including *Kill Bill: Vol. 1*.

J.D. SALINGER
Born in New York City, NY on January 1, 1919, J.D. Salinger is an author best known for his riveting short stories and novels. He wrote the infamous novel *The Catcher in the Rye*, which is still widely studied in English education programs all over the country today.

If I were President I would stop the violent's in ~~the~~ & Schools

Izabel

FROM NYC TO THE WHITE HOUSE FUTURE PRESIDENT

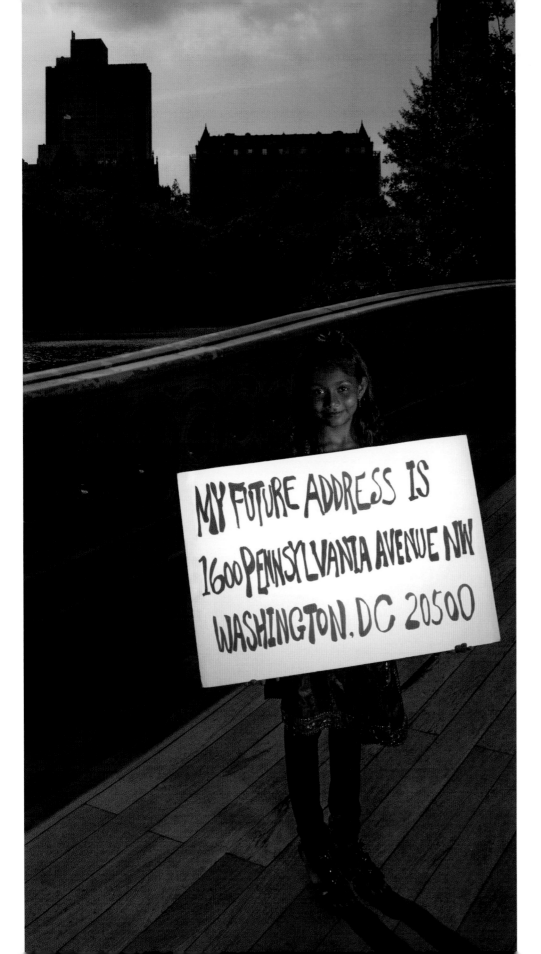

Poppy, 8

JONAS SALK
Jonas Salk was born on October 28, 1914 in New York City, NY. He was a medical doctor and virologist who was the first to successfully create a polio vaccine. He also founded the Salk Center for Biological Studies.

SUSAN SARANDON
Susan Sarandon was born on October 4, 1946 in Queens in New York City, NY. She is an award-winning actress whose career has seen her appear in film favorites such as *The Rocky Horror Picture Show*, *Thelma & Louise*, *The Client*, and *Dead Man Walking*, for which she won the Academy Award for Best Actress. She is also a humanitarian activist and a UNICEF Goodwill Ambassador.

If I was a President I would... Help People. :POPY

OUR BABY IS
THE FUTURE PRESIDENT

NORTH CAROLINA

Danny, 7
Gary, 6
Ricky, 5
Benjamin, 3
Kaleb, 1

TORI AMOS
Piano player, singer, and per-
former Tori Amos was born in
Newton, NC on August 22, 1963.
She is known around the world
for her unique piano-playing
and songwriting style. She was
also the youngest person ever
admitted to the Peabody Con-
servatory of Music, at age five.

HERMAN LAY
Herman Lay was born in Char-
lotte, NC on March 6, 1909. He
was the man who created the
first national brand of potato
chips, Lay's, when he merged
his H.W. Lay & Company with
the Frito Company to form
Frito-Lay.

HIRAM REVELS
The first African American ever
to serve in the U.S. Senate,
Hiram Revels was born in
Fayetteville, NC on September
27, 1827. His appointment held
a great deal of meaning to the
civil rights movement, as the
man who had formerly held that
Senate seat was none other
than Jefferson Davis, the Presi-
dent of the Confederacy.

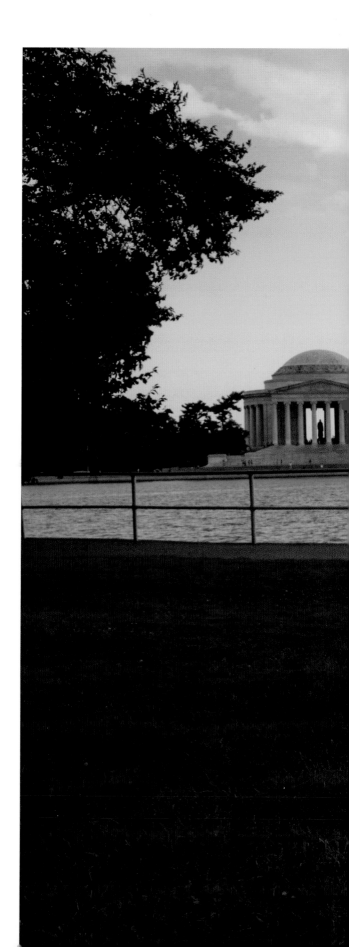

DISTRICT OF COLUMBIA

Claire, 10
Laura, 4
Jasper, 2

DUKE ELLINGTON
Duke Ellington was born on April 29, 1899 in Washington, D.C. He was a jazz composer, band leader, and pianist who is widely considered to be the most prolific composer of the twentieth century.

AL GORE
Al Gore was born in Washington, D.C. on March 31, 1948. He was the 45th Vice President of the United States, and he is also well known for his environmental advocacy.

BILL NYE
Scientist, engineer, and actor Bill Nye "the Science Guy" was born on November 27, 1955 in Washington, D.C. Before his *Bill Nye the Science Guy* TV show, he worked at Boeing where he designed the hydraulic pressure resonance suppressor that is used in their aircraft.

If I was president.......
I would make my sister the vice president. Have fun events for militry kids. Help ones in need from tornado's.
And girls can do anything.

Claire

BEFORE I BECOME PRESIDENT
I WILL SERVE MY COUNTRY
IN THE MILITARY
FUTURE MADAME PRESIDENT

RAYMOND HOOD
Neo-Gothic and Art Deco architect Raymond Hood was born on March 29, 1881 in Pawtucket, RI. Some of his designs include the Tribune Tower in Chicago, IL and Rockefeller Center and Radio Music Hall in New York, NY.

JEFFREY OSBORNE
Jeffrey Osborne was born on March 9, 1948 in Providence, RI. He is an R&B singer, songwriter, and musician best known as the lead singer for the group L.T.D. from 1970 – 1981. He also wrote the lyrics to Whitney Houston's song, "All at Once."

Annie Smith Peck
On October 19, 1850, Annie Smith Peck was born in Providence, RI. She was a famous mountain climber, setting the record for highest climb in the Americas in 1908. She also authored a book about her climbing escapades, entitled *A Search for the Apex of America*.

If we were president we would make sure everyone was kind and everyone had food
RYAN

if I was President I would make sure there were no Bullies.
Alexa
Jocelyn

OUR HOPE
OUR DREAM
OUR GOAL
FUTURE PRESIDENT

Daniel, 9,
Calvin, 11
Calli, 14
Dana, 12
Tamara, 13
Emma, 7
Owen, 8

ELISHA OTIS
We can all feel safer in elevators thanks to inventor Elisha Otis, who was born on August 3, 1811 in Halifax, VT. He invented an elevator safety brake that prevents elevators from falling if the main hoisting cable is compromised.

IP we became president, we would begin our term by lowering farm expenses, raising dairy prices, and helping farms in need.

Some of the other things we would focus on are reducing city growth, lowering prices of healthy food to encourage healthy habits, and stop the talk of global warming.

Several other things we would do would be lowering gas prices, and having the gas companies think before they drill, focus our manufacturing in the USA and not China, and create more job approtunities as we do so. This is how we could improve the US.

Emma Tamara daniell owen
Dana lilli Patty Calli Calvin

WE ARE PLANTING
SEEDS TODAY
FOR A BRIGHT FUTURE
TOMORROW

If I were president, you
Would only go to school in
the afternoon So, you could sleep.
I would have doctors make a medi-
cine for allergies So you could
always have an animal. If you
were smart enough you would
get a good education.

Clara

If I were President...

I would work on protecting
all wildlife and natural places.
I would make sure that every
child has food, water, and a solid
education. College would be free,
maximizing the number of well-
educated people in our country.

Noelle

Clara, 9
Noelle, 13

MARTIN FREEMAN
Martin Freeman was born on
September 11, 1826 in Rutland,
VT. He was the first African
American to hold the office of
College President in the United
States. Freeman held this role
at Allegheny Institute, which
later became Avery College.

HIRAM POWERS
Hiram Powers was born on
July 29, 1805 in Woodstock, VT.
He was a famous neoclassical
sculptor who worked mainly
with marble to create busts and
statues. His most famous stat-
ues are The Greek Slave, Fisher
Boy, and The Last of the Tribe.

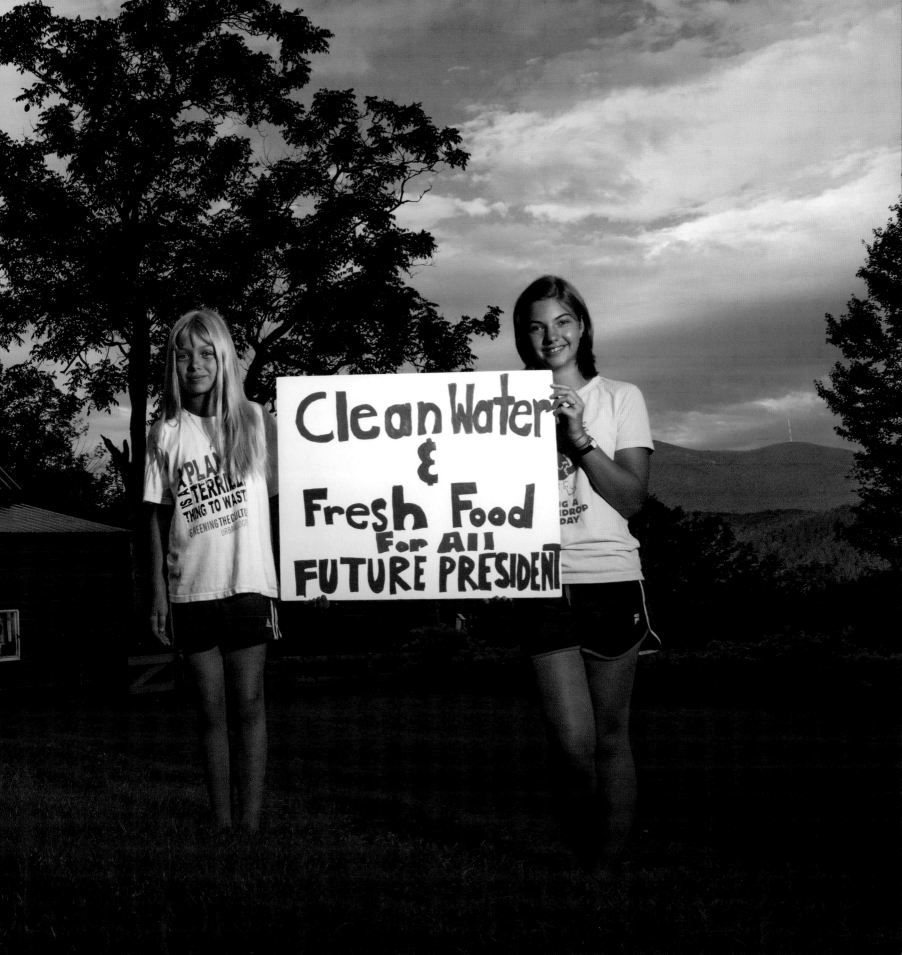

Lillian, 5

MUHAMMAD ALI
Muhammad Ali was born
on January 17, 1942 in
Louisville, KY. He is a
prize-winning boxer and
Olympian gold medalist who
is considered by many to be
one of the best heavyweight
champions in the history of
the sport.

JENNIFER LAWRENCE
Actress Jennifer Lawrence
was born in Louisville, KY
on August 15, 1990. She is
best known for her leading
role in *The Hunger Games*
series of films, as well as
for her role in *Silver Linings
Playbook*, for which she won
an Academy Award for Best
Actress in 2013.

ABRAHAM LINCOLN
Born on February 12,
1809 in Hodgenville, KY,
Abraham Lincoln was the
16th President of the United
States and famously led
the country through the
Civil War. He preserved the
union of the northern and
southern parts of the United
States and brought slavery
to an end.

IF I WAS THE PRESIDENT I WOULD EAT SWEETS EVERY DAY I♥U LILLIAN

LOWELL CUNNINGHAM
Lowell Cunningham was born
on May 21, 1959 in Franklin, TN.
He is a comic writer who is best
known for penning the story for
the *Men In Black* comic series,
which later became a film
series. He also wrote the *Alien
Nation* series of comics.

If I was presIDent I put everyone to work

Josh

OFFICIAL MEMBER
FUTURE PRESIDENTS
CLUB

TENNESSEE

Dylan, 5

ARETHA FRANKLIN
Known as The Queen of Soul,
Aretha Franklin was born on
March 25, 1942 in Memphis, TN.
She is one of the most known
and loved singers in the world,
with over 40 albums and 17
Grammy awards. She was also
awarded the Presidential of
Freedom in 2005.

JACK HANNA
Zoologist Jack Hanna was born
on January 2, 1947 in Knoxville,
TN. He is the former Director
of the Central Florida Zoo and
the Director Emeritus of the Co-
lumbus Zoo. Hanna has made
it his life's work to educate and
inform the public about exotic
and wild animals.

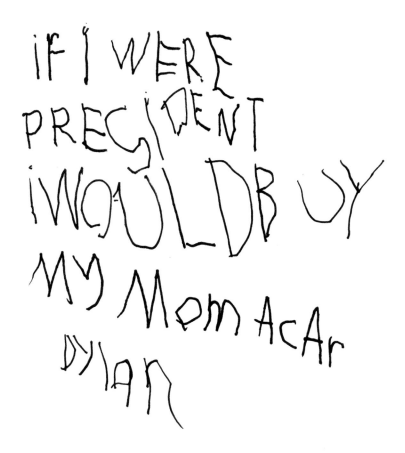

Karrem, 3

NEIL ARMSTRONG
The first person to ever set foot on the moon, Neil Armstrong was born in Wapakoneta, OH on August 5, 1930. He was a naval aviator for three years before joining NASA (NACA at the time of his first recruitment), where he spent 17 years as an administrator, astronaut, engineer, and test pilot.

THOMAS EDISON
Inventor Thomas Edison was born on February 11, 1847 in Milan, OH. He held 1,093 patents, including everything from a method for preserving fruit to his more well-known inventions like the movie camera, the phonograph, and the extended-life light bulb.

CHARLES TURNER
Charles Turner was born in Cincinnati, OH on February 3, 1867. He was an American scientist and pioneer in the field of zoology. Turner was the first to discover that certain insects can learn from experience and modify their behavior.

كريم نثا حبين

٣ سنوات

Karrem

LOUISIANA

Vito, 7

EVELYN ASHFORD
Track and field star Evelyn Ashford was born in Shreveport, LA on April 15, 1957. Ashford won a gold medal at the 1984 Olympics for the 100-meter dash. She also set the world record that same year as the first woman to run 100 meters in less than 11 seconds. In 1992, she won another Olympic gold medal, becoming the oldest woman to win the gold in track and field.

MICHAEL DEBAKEY
Born September 7, 1908 in Lake Charles, LA, Michael DeBakey was a world-renowned surgeon who invented a medical device known as the roller pump. This device would later become a crucial element for allowing doctors to perform open-heart surgery.

SALMAN KHAN
Salman Khan was born in New Orleans, LA on October 11, 1976. He is the founder and Executive Director of the Kahn Academy nonprofit, which aims to provide comprehensive education to anyone in the world through an online tutorial format. He is also the author of *The One World Schoolhouse*.

If I were president I would make everybody pay their taxes.

Vito

INDIANA

Colton, 8

TWYLA THARP
Born in Portland, IN on July 1, 1941, Twyla Tharp is a choreographer and dancer best known for her work for the American Ballet Theatre. She also founded the Twyla Tharp Dance Company at the young age of 23. Tharp won two Emmys for her 1984 TV special *Baryshnikov by Tharp*.

KURT VONNEGUT
Kurt Vonnegut was born in Indianapolis, IN on November 11, 1922. He was an American author of dark yet often humorous stories that examined societal morality. He is best known for his novel, *Slaughterhouse-Five*.

If I was gresident I would geve everone a doter.

Colton

BILL BLASS
Fashion designer
Bill Blass was born in
Fort Wayne, IN on June
22, 1922. He earned
seven Coty Awards over
the course of his career,
as well as the Fashion
Institute of Technology's
Lifetime Achievement
Award.

50 years from now....

I would love for Little Liam to grow
up to be an amazing person who
people will look at and think, "He's
a trust worthy man." I want him to
grow up and follow any dreams he
desires. I hope he grows up to be the
man who says "I can." when everyone
tells him he can't. No matter what I
, know he will make me proud.

FUTURE MR. PRESIDENT 20??

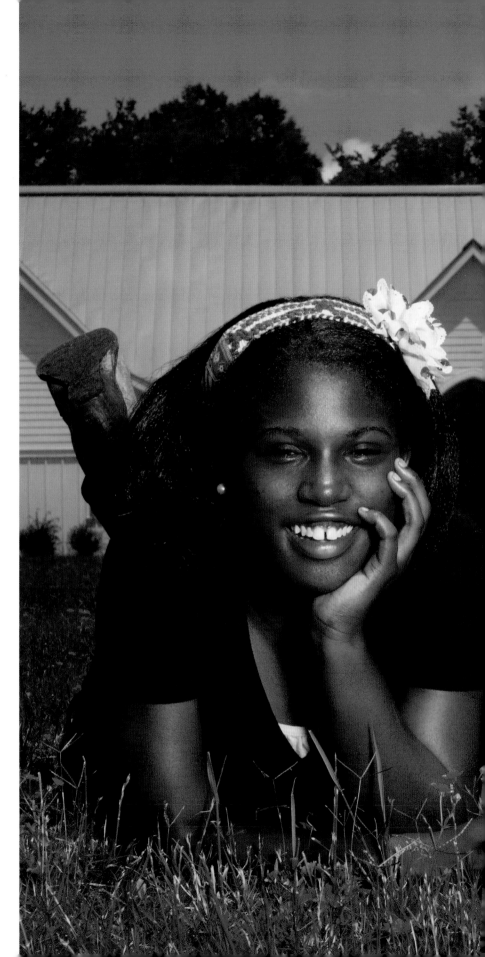

MISSISSIPPI

Kennedy, 12

JIM HENSON
World famous puppeteer Jim Henson was born in Greenville, MS on September 24, 1936. He is best known for his lovable *Sesame Street* characters and his subsequent creation, *The Muppet Show*, which spawned an entire film series.

B.B. KING
Born September 16, 1925 in Berclair, MS, blues musician B.B. King has won 14 Grammys and is considered by many to be one of the greatest guitar players of all time. He has been nicknamed "The King of Blues."

EUDORA WELTY
Author Eudora Welty was born on April 13, 1909 in Jackson, MS. She is best known for her stories about the American South, and earned a Pulitzer Prize for her novel *The Optimist's Daughter* in 1973. She was also awarded the Presidential Medal of Freedom and the French Legion of Honor over the course of her career.

If I were president I would help people to get along with each other. People judge others by what they look like and not what's on the inside. Everyone is special in their own way and there is no need to change!

Kennedy

ILLINOIS

Kymalexa, 5

WALT DISNEY
Born on December 5, 1901 in Hermosa, IL, Walt Disney was a famous cartoonist, filmmaker, and businessman. He co-founded Walt Disney Productions with his brother Roy, and famously created the Mickey Mouse character. He also co-created the Disneyland and Walt Disney World theme parks.

IF I was a President I would make everyone a Prince and a Princess.

Jacob, 8

ELLIOT HANDLER
Elliot Handler was born
in Chicago, IL on April
9, 1916. He co-founded
toy company Mattel, Inc.,
where he and his wife
created some of the
most popular toy brands
in the world, including
Hot Wheels, Barbie,
Fisher-Price, and
American Girl.

JENNIFER HUDSON
Singer and actress Jen-
nifer Hudson was born
on September 12, 1981 in
Chicago, IL. She first hit
the spotlight as a finalist
on the third season of
American Idol, then went
on to win an Academy
Award for Best Supporting
Actress for her role in the
film *Dreamgirls* and later
a Grammy for her debut
album *Jennifer Hudson*.

if I were
a presidend
I would
make shure
everyone had food.
Jacob

I HAVE A DREAM
FUTURE PRESIDENT

MAE JEMISON
Astronaut and medical
doctor Mae Jemison was
born in Decatur, AL on
October 17, 1956. She
studied both engineering
and medicine and joined
the NASA astronaut
program in 1987. In 1992,
Jemison became the first
African American woman
to travel in space.

Savannah 7 years old

If I was

President...

I would

rebuild Oklhoma

from the tornado

HELEN KELLER
Helen Keller was born in
Tuscumbia, AL on June
27, 1880. In addition to
being the first deaf, blind,
and mute person to earn
a Bachelor of Arts degree,
she also co-founded the
American Civil Liberties
Union (ACLU). She is an
amazing example of how
we can overcome adver-
sity to succeed in life and
advocate for ourselves and
others.

E.O. WILSON
Edward Osborn Wilson
was born in Birmingham,
AL on June 10, 1929. He is
a scientist and biological
researcher who is con-
sidered to be the world's
foremost authority on
ants, the study of which
is called myrmecology.
He is also the author of
several books, including
The Diversity of Life.

If I were presedent
I would put P;E
Progams in public
sistums. Jayden

ONE DAY
I WILL SIT IN
THE OVAL OFFICE
AS THE PRESIDENT

MILTON BRADLEY
Considered by many to
be the founding father
of the board game
industry, Milton Bradley
was born in Vienna, ME
on November 8, 1836.
He later owned the first
lithography shop in
Massachusetts, where
he devised and created
*The Checkered Game of
Life* (the original version
of what we now know
as *The Game of Life*). He
was also an outspoken
advocate for the impor-
tance of early childhood
education.

If I were Preident
I Would Help People
in need, try to make
Peace in the world, Make
stuff less expensive, give
Money to churches, Make
a fund for children that are
less fourtunate, and
finall I would be a good
President, that helps
People

Andrew

If I were president
I would lower
Prces for Gas. I would
help the poor people.
I wouldgive to famrin.
I would help the unfor,
tunate.

Nicholas

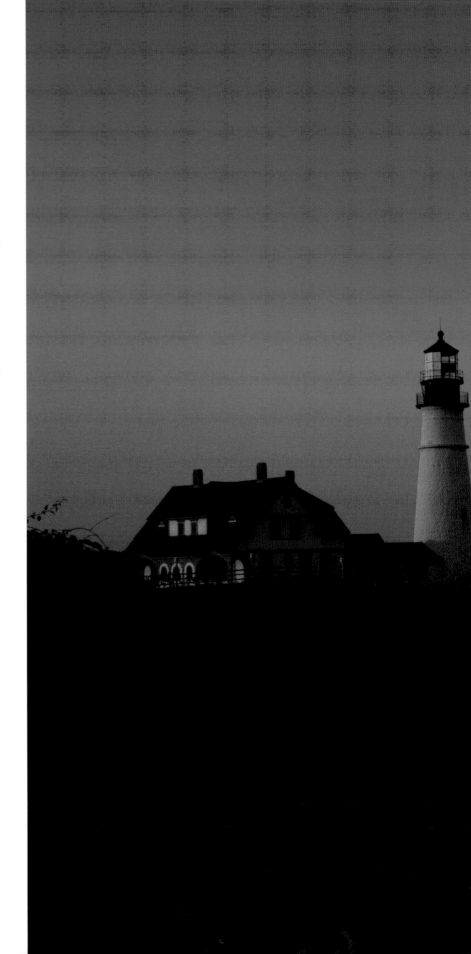

MAINE

Bonge, 13

MONIQUE EDWARDS
Monique Edwards was born
in Kittery, ME on April 1,
1968. She is a multi-tal-
ented star of television and
film who has appeared in
shows such as *The X-Files*,
Everybody Loves Raymond,
and *NYPD Blue*. She is also a
dedicated humanitarian aid
worker and Ugandan peace
activist.

STEPHEN KING
New York Times bestselling
author Stephen King was
born in Portland, ME on
September 21, 1947. His
novels and short stories
range from horror to fantasy
to science fiction. King has
also written for the screen
as well as for the stage,
collaborating with John
Mellencamp for the pair's
musical, *Ghost Brothers of
Darkland County*.

If I were
President, I would
make human beings
love each other with-
out regard to race.
 -Bonge

ONE DAY I WILL
TRADE THE LIGHTHOUSE
FOR THE WHITE HOUSE

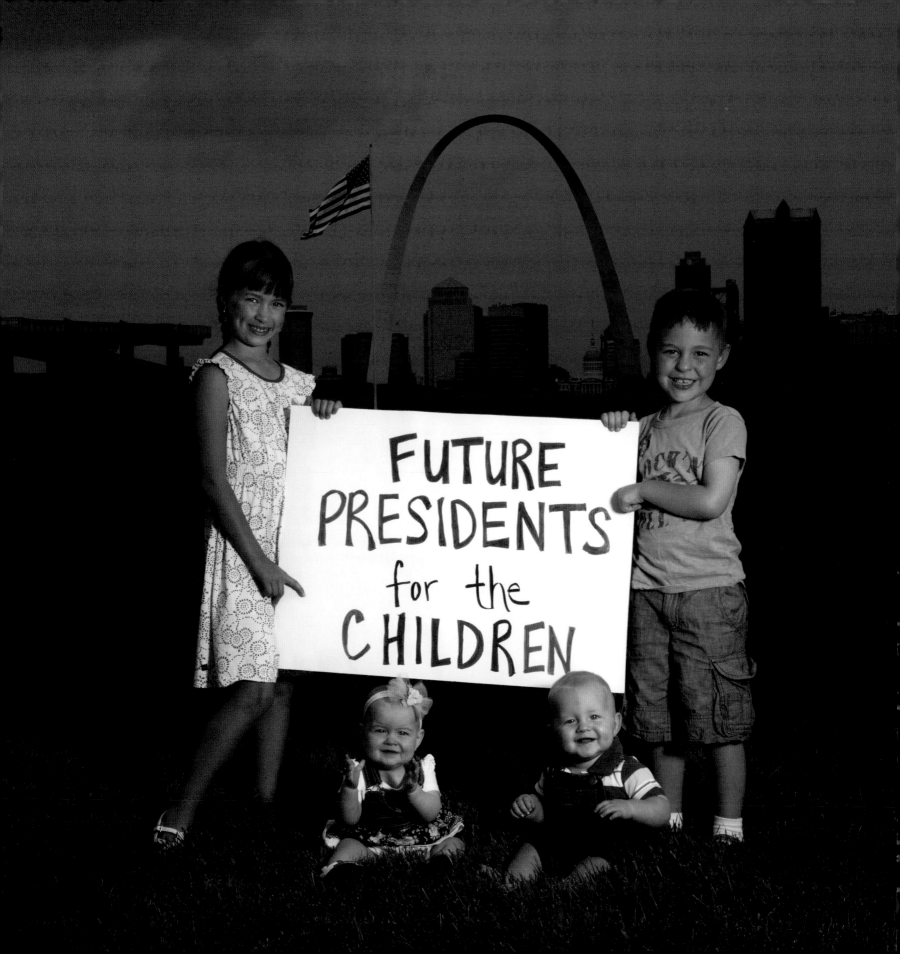

MISSOURI

Madison, 9
Logan, 6
Quinn, 1
Riley, 1

MISTY COPELAND
Born in Kansas City, MO on September 10, 1982, Misty Copeland is a ballet dancer and soloist for the American Ballet Theatre. She has spoken publicly about breaking ballet stereotypes as an African American woman and encourages young women of all ages, colors, and creeds to follow their dreams.

WALKER EVANS
Photographer Walker Evans was born in St. Louis, MO on November 3, 1903. He is best known for his intensely human portrayal of the effects of the Great Depression. His moving portraits and unabashed realism influenced generations of photographers.

AL HIRSCHFELD
Al Hirschfeld was born in St. Louis, MO on June 21, 1903. He was an illustrator, painter, and sculptor best known for his caricatures of celebrities for *The New York Times*. He also drew many famous movie posters, including *The Wizard of Oz* and several Charlie Chaplin films.

If I where president I would improve egdection across Amierca to help people aer who are not egdectaed.
Madison

If I weref uture president I would make evryone recycle. It would mak theer the greener
Logan

ARKANSAS

Alyssa, 3

JOHN GRISHAM
Born February 8, 1955 in
Jonesboro, AR, John Grisham
is a lawyer and author who
is best known for his riveting
novels based on legal themes.
He is also a legal advocate for
those who have been wrongly
imprisoned, working to free
people through DNA evidence
in his work with nonprofit group
the Innocence Project.

LEVON HELM
Levon Helm was born in Elaine,
AR on May 26, 1940. He is
best known as the drummer
and lead singer for famed
rock group, *The Band*. He also
appeared in several films,
including *Coal Miner's Daughter*
and *The Right Stuff*.

JOHN H. JOHNSON
Publisher and businessman
John H. Johnson was born in
Arkansas City, AR on Janu-
ary 19, 1918. He founded the
Johnson Publishing Company,
whose publications include
popular magazines *Ebony* and
Jet. He was also the first
African American to appear on
the Forbes 400.

World Peace
aly

WILLIAM BOEING
Born October 1, 1881 in Detroit, MI, William Boeing went into the aircraft business shortly after learning to fly. He revolutionized airplane quality and craftsmanship, creating planes for the US government and later for commercial use.

STEVIE WONDER
Stevie Wonder was born in Saginaw, MI on May 13, 1950. In spite on going blind shortly after birth, Stevie taught himself to play piano, harmonica, and drums before the age of 10. He went on to become one of the most respected and loved musicians in the world, and was inducted into the Rock and Roll Hall of Fame in 1989.

If I were president, I would try to create a non-violent community, where evryone is educated and wealthy, and can chace their dreams freely.

Isaac

I WILL PRESERVE PROTECT AND DEFEND THE CONSTITUTION

WHEN I AM PRESIDENT I PROMISE TO ALWAYS TELL THE TRUTH

MICHIGAN

Layla, 5

JOHN SHEEHAN
John Sheehan was born
on September 23, 1915
in Battle Creek, MI.
He was a scientist and
organic chemist and is
best known for being
the first to synthesize
penicillin, allowing for
mass production of these
life-saving antibiotics.

I WILL NEVER. LIE Layla

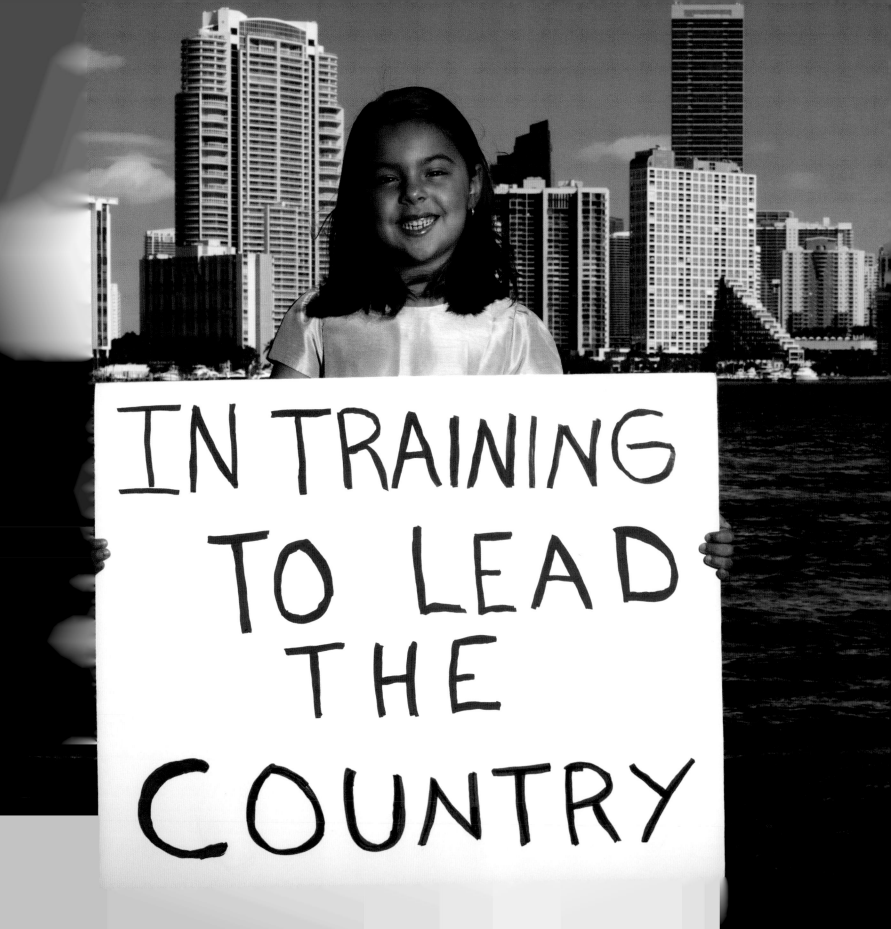

FLORIDA

Ava, 6

EVA MENDES
Actress Eva Mendes was born on March 5, 1974 in Miami, FL. She acts in a variety of film genres, and is best known for her roles in *Training Day*, *Once Upon a Time in Mexico*, and *2 Fast 2 Furious*, among others. She is also a Revlon spokeswoman and is an active voice in the fight for a cure for breast cancer.

SIDNEY POITIER
Born in Miami, FL on February 20, 1927, actor Sidney Poitier won the Academy Award for Best Actor for his role in *Lilies of the Field*. He was the first African American to win the Oscar for Best Actor. He has been honored numerous other times for his acting and directing, and has served as the Bahamian ambassador to Japan since 1997. Poitier was awarded the Presidential Medal of Freedom in 2009.

BRETT RATNER
Brett Ratner was born in Miami Beach, FL on March 28, 1969. He is a successful film producer and director who has made such hits as *X-Men: The Last Stand*, the *Rush Hour* film series, and *Red Dragon*.

I would have fun. Ava

IF I were President I would give People Free health care For everyone

Blake

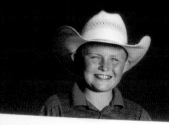

SELENA GOMEZ
Selena Gomez was born in
Grand Prairie, TX on July 22,
1992. She is a singer and
actress who got her start
acting in a variety of Disney
television programs and
films. She released her first
music album, *Kiss & Tell*, in
2009 and it reached the Top
10 of the Billboard music
charts.

If I were president
I would cut down
all the Smoke from
the factories

Adison

I VOW TO WORK
FOR THE GOOD
OF ALL PEOPLE

Leslie, 7

LOLO JONES
Lolo Jones was born in Des Moines, IA on August 5, 1982. She is an all-star Olympic athlete who competes in track and field and bobsledding. At the time of this writing, she holds the American record for fastest 60-meter hurdles.

GEORGE NISSEN
Born on February 3, 1914 in Blairstown, IA, George Nissen is credited with inventing the folding trampoline and popularizing trampoline jumping throughout the world. He pushed for it to become recognized as an official sport and succeeded. Trampoline jumping was introduced into the Olympic Games in 2000.

JOHN RINGLING
John Ringling was born in McGregor, IA on May 31, 1866. He and four of his brothers formed the Ringling Brothers Circus, which they later merged with the Barnum & Bailey Circus. Eventually, he owned the entire American traveling circus business.

I WoLe het PeBo
LeSlie

WISCONSIN

Alexis, 6
Alejandro, 8
Alexandre, 13

GENE WILDER
Gene Wilder was born on
June 11, 1933 in Milwaukee,
WI. He is an actor known
for his delightful come-
dic performances in films
such as *Willy Wonka and the
Chocolate Factory* and *Young
Frankenstein*. Wilder has also
authored several books and
is an active voice in finding a
cure for ovarian cancer and
promoting early detection.

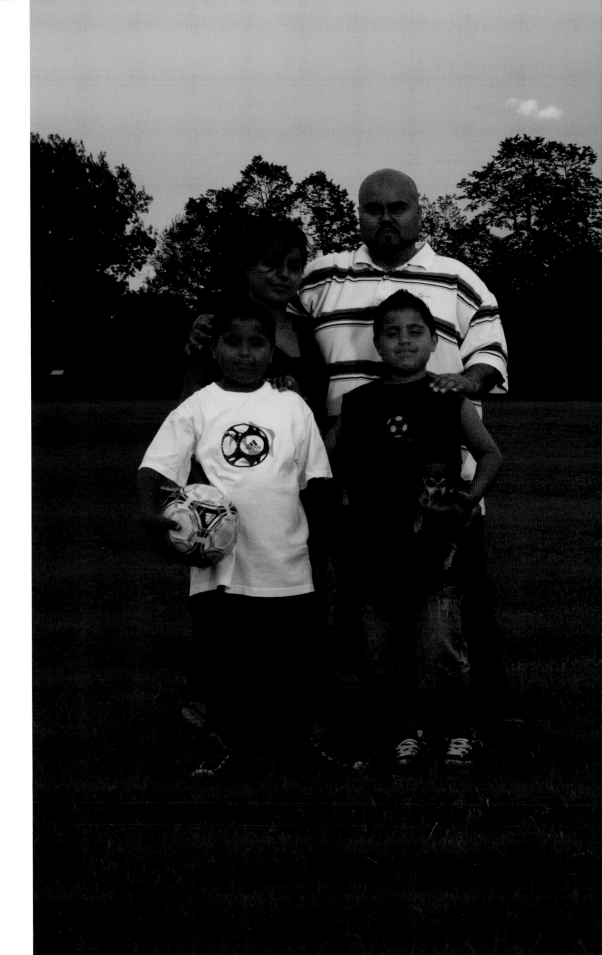

I WILL FAITHFULLY EXCUTE THE OFFICE OF PRESIDENT OF THE UNITED STATES

If I was the president I will stop the war

Alexis

If I was the President I will destroyed the weapons

Alejandro

I would help better ways of Protecting the world.

WISCONSIN

Jayda, 8

FRANK LLOYD WRIGHT
Born on June 8, 1867
in Richland Center, WI,
Frank Lloyd Wright was a
famous architect who de-
signed hundreds of build-
ings in his unique prairie
style. Some of his most
famous works include the
Imperial Hotel in Tokyo,
Japan, The Park Inn Hotel
in Mason City, IA, and the
Guggenheim Museum in
New York City.

SHEILA TOUSEY
Sheila Tousey was born on
June 4, 1960 in Keshe-
na, WI. She is a Native
American theater, tele-
vision, and film actress
who starred opposite
Val Kilmer in the film
Thunderheart. She is also
a professional dancer.

iF I Was Presidents
I Would share

JAYDA

BEN RATTRAY
Ben Rattray was born
June 16, 1980 in Santa
Barbara, CA. He is
the Founder and CEO
of the online petition
website Change.org.

If I were president I would plant more trees for the environment.

Kaitlyn

JAMES FRANCO
Actor James Franco was
born in Palo Alto, CA on
April 19, 1978. He has
starred in numerous films,
such as *James Dean*,
the *Spiderman* trilogy,
Pineapple Express, and
Milk. Franco also published
a book of short stories,
entitled *Palo Alto*.

If I were President I would make the Poor rich and the rich richer.

Joshua Josiah

CALIFORNIA

Jillian, 9

ROBERT FROST
Famed poet Robert
Frost was born in San
Francisco, CA on March
26, 1874. He won four
Pulitzer Prizes for
Poetry as well as a
Congressional Gold
Medal. Perhaps Frost's
most well-known work
is his poem, "Stopping
by the Woods on a
Snowy Evening."

If I were president I would end world hunger.

Jillian

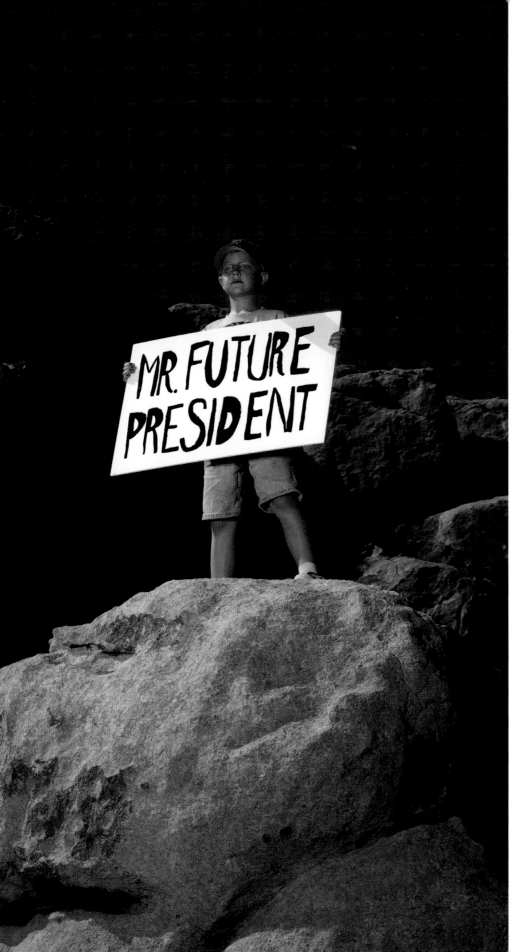

CALIFORNIA

Joshua, 7

SALLY RIDE
A physicist and
astronaut, Sally Ride at
the age of 32, became
the first American
woman in space. She
was born May 26, 1951
in Los Angeles, CA.

If I were
president I would...
give the people what they
want.

Joshua

117

TYRA BANKS
Tyra Banks was born in
Inglewood, CA on
December 4, 1973. She
is well known for her
successful modeling
career as well as her role
as host of the television
series *America's Next
Top Model*. *Time* magazine
has called her one the
world's most influential
people.

If I were president,
I would make sure people
are happy and people don't
Fight.

Slatter

If I were president, I
would educate every child
and make sure everybody
gets along.

Bronwyn

FUTURE
TWIN
PRESIDENTS
2072 2060

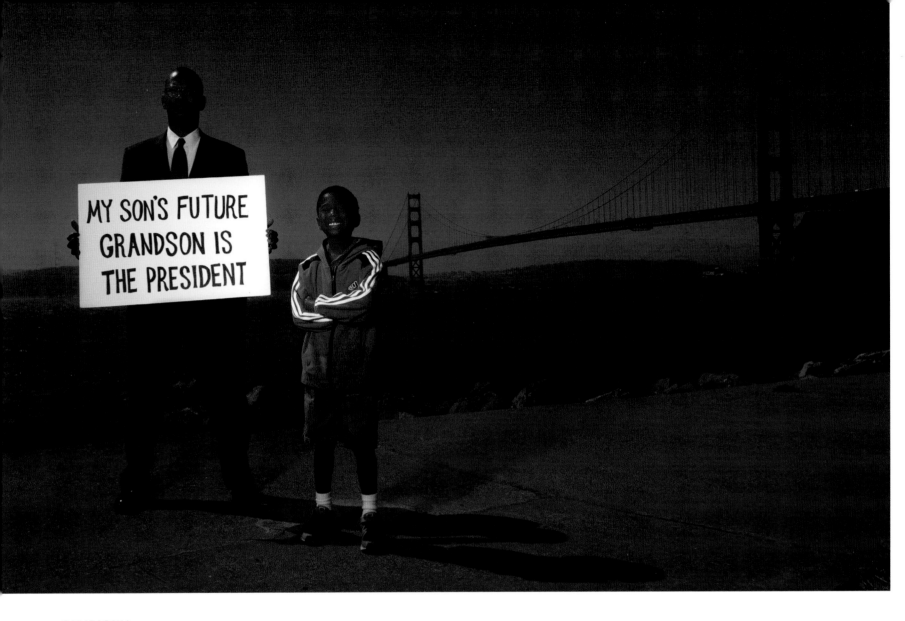

CALIFORNIA

William, 6

GEORGE LUCAS
Born May 14, 1944 in Modesto, CA, George Lucas is a film writer, director, producer, and founder of the Lucasfilm company. Some of his most famous movies include the *Star Wars* series, *American Graffiti*, and the *Indiana Jones* films.

If I were President I would tell everyone to be nice.

William

If I was a PresidenT, I would like to help The latin people, and also The poor people that does noT have anything To eat.

Si soy una Presidente quisiera ayudar a todos los latinos, y gente pobre que no tiene para comer.

Teresita

CALIFORNIA

Teresita, 6
Jorge, 11
Ernesto, 9

RONDA ROUSEY
Ronda Rousey was born in Riverside, CA on February 1, 1987. She is a martial arts champion, Pan American Championships gold medalist, and an Olympic bronze medalist. She is currently in the mixed martial arts circuit and holds the title of UFC Women's Bantamweight Champion.

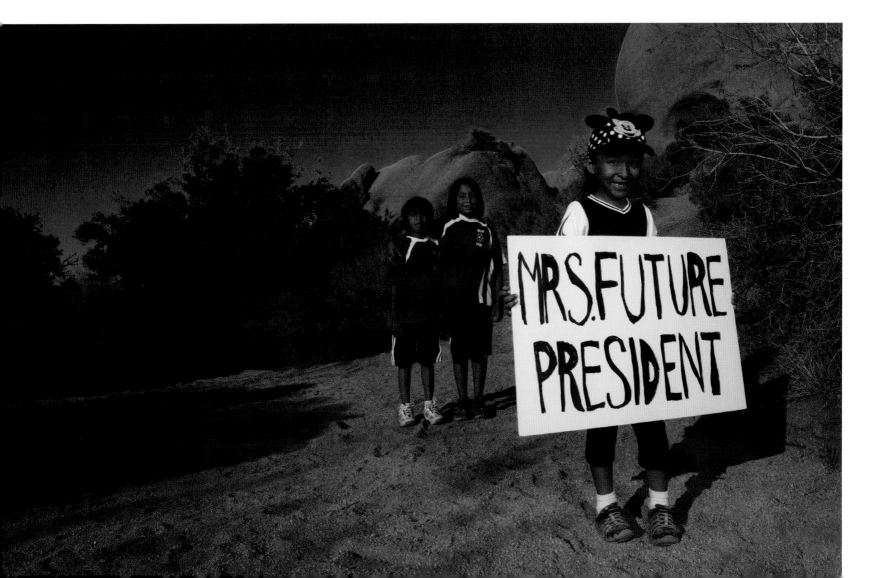

Jayden, 9

JOHN STEINBECK
John Steinbeck was born
February 27, 1902 in
Salinas, CA. He was a Pulit-
zer Prize-winning
novelist who was awarded
the Nobel Prize for
Literature in 1962.

If I were President
I would...

Make sure everyone is
treated equally.

ヴェイデン

Houston, 6

SHAUN WHITE
Born in San Diego, CA on September 3, 1986, Shaun White is widely considered to be one of the best skateboarders and snowboarders in the world. He has won two Olympic gold medals, 10 ESPY Awards, and to date holds the record for most gold medals and most overall medals received by any individual in the X-Games.

If I were The President I would change The Laws and make children safe at school.

Houston

MY DREAMS & DEEDS WILL MAKE HISTORY

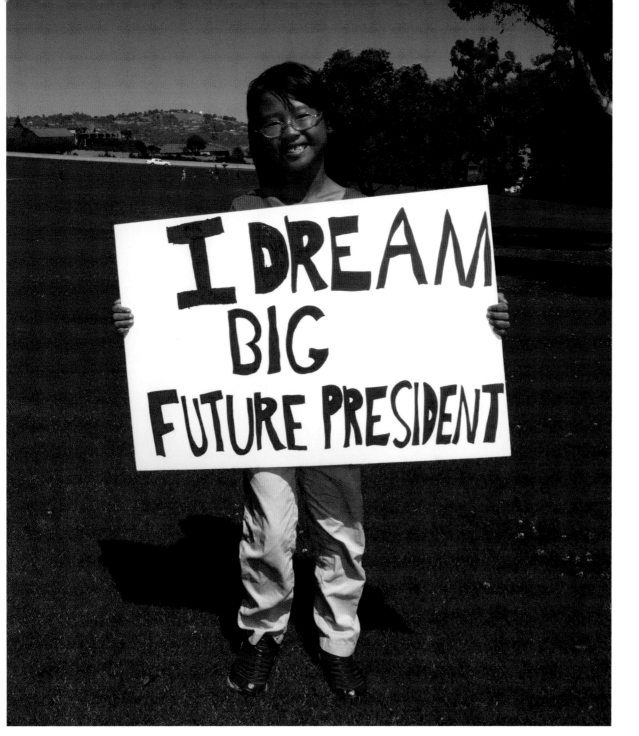

CALIFORNIA

Mikn, 7

JULIA CHILD
Julia Child is recog-
nized for bringing
French cuisine to the
American public, with
her debut cookbook,
*Mastering the Art of
French Cooking*, and
her subsequent tele-
vision programs. She
was born August 15,
1912 in Pasadena, CA.

I would help ~~pepp~~people if I were
a president.

Min

내가 대통령 이되 면
사람들을 듣고싶어요.

김민정

Esmeralda, 10

PAT MORITA
Pat Morita was born
on June 28, 1932 in
Isleton, CA. He was
a television and film
actor best known for
his roles as Matsuo
"Arnold" Takahashi
on *Happy Days*
and Mr. Miyagi in *The
Karate Kid* film series.

If I was President I would help
the Poor and help Other Kids
with the same Problem as me.

Esmeralda

Sophie, 7
Nico, 5

BRIAN WILSON
Brian Wilson was born on
June 20, 1942 in Ingle-
wood, CA. He is a singer,
songwriter, and bass guitar
player, and music producer
best known for his time in
the band *The Beach Boys*,
which he co-founded.
Rolling Stone magazine
voted him one of the
100 Greatest Singers of
All Time.

If I were president,
I would stop robbery,
and make fair laws so every
body will get a long.

Sophie

MY SISTER IS THE FUTURE PRESIDENT

MINNESOTA

Tayvion, 6
Tatiyona, 7

CHARLES SCHULZ
Charles Schulz was born
on November 26, 1922
in Minneapolis, MN. He
is best known for his
creation of the *Peanuts*
comic strip. He set
the stage for modern
day cartoons, and
many cartoonists claim
Schulz's work as a great
source of inspiration.

I would give a speech.

To be kind to others.
Don't be mean to others.
Live your own life.
I love you Guys.

Tayvion

Te donnerais un
discours:
"Soyez Gentils.
ne soyez pas méchants.
Profitez de la vie.
Te vous aime."

If i was a president i
would like to know all languags
have more students speak french.
Tativona.

si J'étais President

J'aimerais savoir parler
toutes les langues et
apprendre aux enfants
à parler français.

131

WITH INTEGRITY
I WILL LEAD
OUR COUNTRY

MINNESOTA

Jameson, 4

GARRISON KEILLOR
Born on August 7, 1942 in Anoka, MN, Garrison Keillor is a writer and radio personality best known for his National Public Radio show, *A Prairie Home Companion*. He has also authored several books and owns a small bookstore.

PRINCE
Prince Rogers Nelson, known by millions simply as Prince, was born on June 7, 1958 in Minneapolis, MN. He has released 32 albums to date, of which ten went platinum. He has earned seven Grammys and produced thirty Top 40 singles over the course of his career.

If *I* were president...

"I would hang out with my mom!"

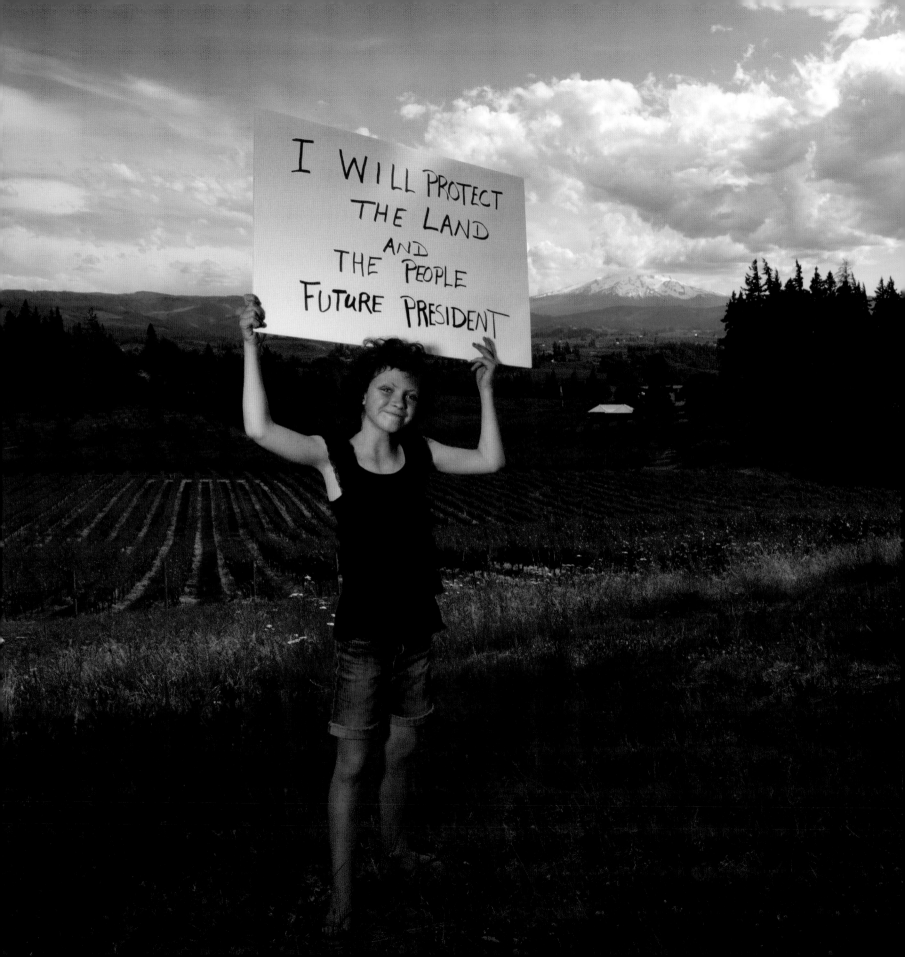

OREGON

Mia, 11

TERRI IRWIN
Born on July 20, 1964 in Eugene, OR, Terri Irwin is a wildlife expert, conservationist, author, and owner of the Australia Zoo in Beerwah, Queensland. She co-starred with her late husband Steve Irwin on *The Crocodile Hunter*. Irwin was made an honorary member of the Order of Australia in 2006 for her contribution to wildlife preservation in the country.

HINMATÓOWYALAHTQ'IT "CHIEF JOSEPH"
Chief Joseph was born on March 3, 1840 in Wallowa River, OR. He led the Wallowa-area band of the Nez Perce tribe through a very difficult period in the tribe's history. His efforts to protect and serve his people earned him a reputation as a peacemaker and humanitarian.

If I was the future President, I would help people that need help.

Mia

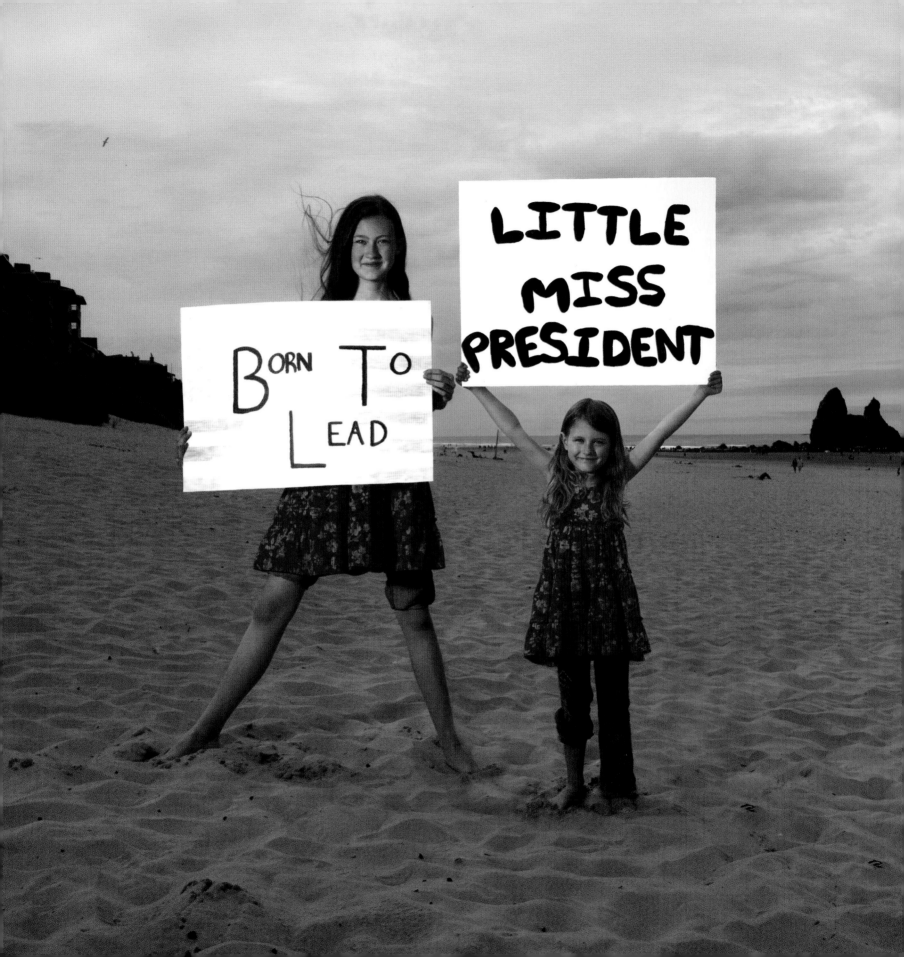

McKenna, 12
Serene, 6

ESPERANZA SPALDING
Singer, cellist, and
bass player Esperanza
Spalding was born on
October 18, 1984 in
Portland, OR. She is
a genre-crossing jazz
musician who has won
four Grammys, includ-
ing a Grammy for Best
New Artist in 2011.

If I were president of the United States of America, I would help feed and house all homeless people that live in the USA, and in other countries. I would encourage people all around the globe to make peace & interact with one-another in a friendly way.

— McKenna

If I were the president I would make sure that all people had good food and water.

serene

MY YELLOW BRICK ROAD LEADS TO THE PRESIDENCY

Jayden, 9
Jeremy, 7

ROBERT BALLARD
Deep-sea diver,
oceanographer, and
professor Robert Ballard
was born on June 30,
1942 in Wichita, KS.
His celebrated work in
underwater archaeology
includes his famous
discovery of the wreck-
age of the Titanic.

CHARLES CURTIS
Born January 25, 1860
in Topeka, KS, Charles
Curtis was the 31st Vice
President of the United
States and the first per-
son of Native American
ancestry to hold this
office. Prior to serving
as Vice President, Curtis
was a Kansas Senator.

AMELIA EARHART
Amelia Earhart was
born on July 24, 1897 in
Atchison, KS. She is best
known for being the
first woman to fly solo
across the Atlantic, and
she was also the first
person ever to do so
twice. She received the
Distinguished Flying
Cross award in 1932.

If I where the Pesident every thing whould be fair no one whould feel leafedout or alone no one whould be poor or unkind every one whould be nice and kind and share with others

Jayden

If I where the Pesident I whould be fair no one whould be leaftout mean or ankind and every one whould be kind

Jeremy

WEST VIRGINIA

Allenah, 12

MARY LOU RETTON
Olympic gymnast Mary Lou Retton was born on January 24, 1968 in Fairmont, WV. She won five medals in the 1984 Olympics and was voted Sportswoman of the Year by *Sports Illustrated* magazine. Retton later became a member of the President's Council on Physical Fitness and Sports.

JOHN NASH
John Nash was born on June 13, 1928 in Bluefield, WV. He is the famous mathematician on which the film *A Beautiful Mind* was based. Nash contributed a great deal to the study of the mathematical factors that affect chance. He served as a Senior Research Mathematician at Princeton University for a time, and was also recognized as part of a group of mathematicians who received the Nobel Memorial Prize in Economic Sciences.

STEVE HARVEY
Born January 17, 1957 in Welch, WV, comedian, author, actor, and television and radio personality Steve Harvey is perhaps best known as the host of the popular TV show, *Family Feud*.

If I were too be president I would lower gas prices so people can save money. I would provide universal healthcare. I would bring the troops home for war. I would pay teachers more for ~~thier~~ hard work. I will go to local charaties, orphanages, after school places such as the Boys and Girls Club to donate.

Allenah

I ♥ Photography

IN THE MOUNTAIN STATE
WE LEARN TO CLIMB HIGH
FUTURE PRESIDENT

NEVADA

Chase, 6

ANDRE AGASSI
Born on April 29, 1970
in Las Vegas, NV, Andre
Agassi is an Olympic gold
medalist tennis player.
He earned the title of ITF
World Champion in 1999,
as well as ATP Player
of the Year. He is widely
considered to be one the
greatest tennis players in
the history of the sport.

Kyle Busch
Kyle Busch was born in
Las Vegas, NV on May 2,
1985. He is a racecar driver
and holds several NASCAR
competition records,
including most race wins
in a single season. He is
the youngest driver ever to
qualify for the Chase Sprint
Cup and the only driver
ever to win four spring
races in a row at Richmond
International Raceway.

I would change Taxes. chase

ANNIE BRONN
JOHNSTON
Also known as "Wild
Horse Annie," Annie
Bronn Johnston was
born in Reno, NV on
March 5, 1912. She
was an animal rights
activist who fought
to protect the wild
mustangs and burros
on the public lands in
Nevada. She succeed-
ed, and the Wild and
Free-Roaming Horses
and Burros Act of 1971
was signed into law
by President Nixon.

Lets all be
happy!
(The future
president)
Anthony

I will see
a girl President.
(A future
president)
Ava

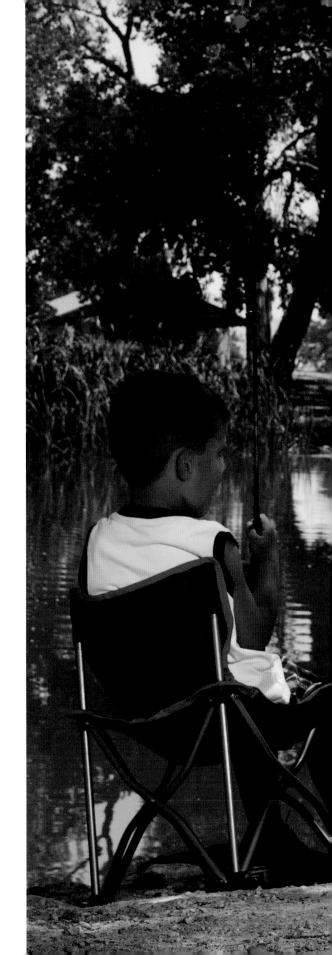

FUTURE
PRESIDENT
2064

Ethan, 6
Aaron, 11

JAMES E. CASEY
James E. Casey
was born in Pick
Handle Gulch, NV on
March 29, 1888. He
founded the American
Messenger Company,
which later became
United Parcel Service
(UPS). He also created
the Casey Family Pro-
grams, the country's
largest foster care
foundation, as well
as the Annie E. Casey
Foundation, which
aims to support disad-
vantaged children and
their families.

If I were president, I would send money to the people who need food and a house to live in. And I would also lower prices so people can buy more items they need for their family

Aaron

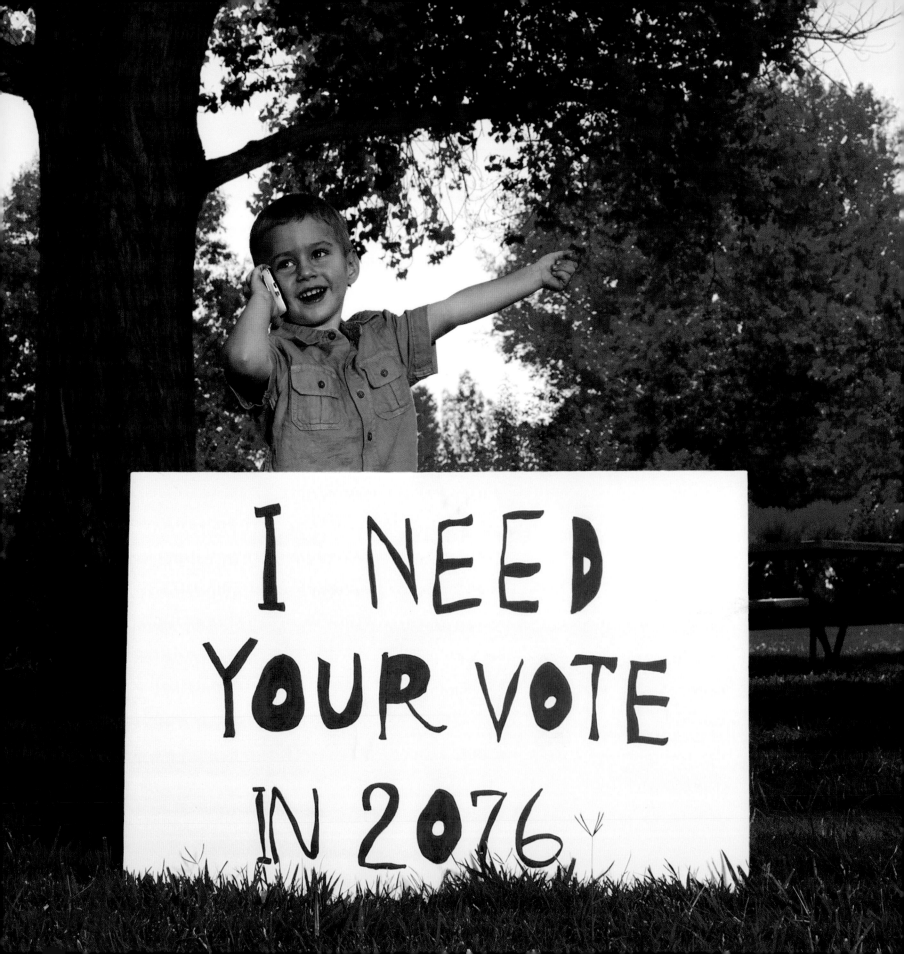

NEVADA

Talen, 2

TONY MENDEZ
Tony Mendez was
born in Eureka, NV on
November 15, 1940. He
served as a technical
operations officer
in the CIA for 27 years.
After retiring form
service, he wrote a
series of memoirs
about his experiences.
The award-winning
film *Argo* was based
on his handling of
the Iran hostage crisis
in January of 1980.

RUTINA WESLEY
Rutina Wesley was born
in Las Vegas, NV on
February 1, 1979. She
is a theater, film, and
television actress best
known for her role in
the popular HBO series,
True Blood. Wesley
also did voiceover work
for *Family Guy* spinoff
The Cleveland Show.

TOCMETONE "SARAH
WINNEMUCCA"
Born in 1844 in Nevada,
Sarah Winnemucca,
daughter of Chief
Winnemucca of the
Paiute tribe, is credited
as publishing the first
known autobiographical
work by a Native
American woman,
*Life Among the Paiutes:
Their Wrongs and
Claims*. She was a
strong and respected
advocate against the
mistreatment of Native
American peoples
in the United States.

Brayden, 7
Keagan, 5

FRED ASTAIRE
Dancer, choreographer, and actor Fred Astaire was born in Omaha, NE on May 10, 1899. The American Film Institute named him the fifth Greatest Male Star of All Time. He starred in 31 musical films and is best known for his dancing and singing duets with onscreen partner, Ginger Rogers.

GEORGE WELLS BEADLE
Geneticist George Wells Beadle was born on October 22, 1903 in Wahoo, NE. His scientific study of genetic mutation earned him a Nobel Prize, and he later became the President of the University of Chicago.

JOHN TRUDELL
John Trudell was born on February 15, 1946 in Omaha, NE. He is an actor and writer with a long history of activism on behalf of the people of the First Nations. He appeared in the film *Thunderheart* and also served as an advisor to the documentary film *Incident at Oglala*. The documentary *Trudell* is about his life's work.

If I was president I would give people food!

Brayden

Keagan

NEBRASKA,
POSSIBILITIES...ENDLESS
FUTURE PRESIDENT

COLORADO

Madison, 7

INDIA ARIE
India Arie was born in Denver, CO on October 3, 1975. She is a singer, songwriter, and record producer who has won four Grammys for her musical work. She is also an actress, and has appeared on television, in film, and on theatrical stage.

TREY PARKER
Born in Conifer, CO on October 19, 1969, Trey Parker is an animator and screenwriter best known as one of the co-creators of the TV series, *South Park*, for which he has received five Emmys. He also co-wrote the Broadway comedic musical, *The Book of Mormon*, which earned him nine Tony Awards and a Grammy.

FLORENCE SABIN
Born in Central City, CO on November 9, 1871, Florence Sabin was one of the first U.S. women working in the medical science field. She was the first woman to become a full professor at Johns Hopkins University, the first woman chosen as a department head at Rockefeller Institute, and the first woman elected to the National Academy of Sciences.

If I were President I would make sure evryone would be safe and that no one would be robbed. Madison

153

NORTH DAKOTA

Myka, 3

SHANNON MARIE CURFMAN
Born in Fargo, ND on
July 31, 1985, Shannon Marie
Curfman is a prodigious rock
and blues guitar player
who recorded her first album
at the age of thirteen. She
has since been invited to
appear on *The Tonight Show
with Jay Leno* and *Late Show
with David Letterman*, and
she has worked as a touring
musician sharing the
stage with the likes of
The Indigo Girls, Buddy Guy,
and John Mellencamp.

LEON JACOBSON
Dr. Leon Jacobson was born
on December 16, 1911 in
Sims, ND. He made great
strides in medical research of
cancer treatment, particularly
in the area of chemotherapy.
He founded the Argonne
Cancer Research Hospital,
now known as the
Franklin McLean Memorial
Research Institute.

THOMAS MCGRATH
Poet Thomas McGrath was
born in Sheldon, ND on
November 20, 1916. He wrote
thirty books of poems,
around twenty movie scripts,
and two novels. The film
*The Movie at the End of the
World* is a documentary about
McGrath's life and work.

MYRON FLOREN
Born on November 5, 1919 in Roslyn, SD, accordion player Myron Floren rose to fame as the accordionist on *The Lawrence Welk Show*. He was also a music educator and composer who wrote and performed for a variety of television and film productions.

ERNEST LAWRENCE
Physicist and nuclear scientist Ernest Lawrence was born in Canton, SD on August 8, 1901. He invented a device called the cyclotron, which creates high-energy beams for use in experimental nuclear physics work. The device can also be used to treat cancer patients with targeted particle therapy that can isolate and destroy tumors with minimal damage to surrounding tissues.

If I were president I would let all people have the right to freely come to the United States of America. They all deserve the chance.

JJ

SOUTH DAKOTA

Rosa, 10
On vacation from Ohio

RUSSELL MEANS
Civil rights leader Russell
Means was born on the
Pine Ridge Indian Reser-
vation, SD on November
10, 1939. He made speak-
ing out and organizing on
behalf of the indigenous
peoples of the United
States his life's work. He
also appeared in several
films, including *The Last of
the Mohicans*.

If I were president I
would work to solve world hunger,
world peace, and I would work
to lower taxes.

Rosa

MONTANA

Paige, 4

MAURICE HILLEMAN
Dr. Maurice Hilleman was born in Miles City, MT on August 30, 1919. He was a microbiologist and medical doctor who created more than 40 vaccines, including those for measles, mumps, and hepatitis B.

JACK HORNER
Born June 15, 1946 in Shelby, MT, Jack Horner is one of the world's leading paleontologists. He was the first to prove that some dinosaurs cared for their young. Horner was also the technical advisor for the *Jurassic Park* films, helping the filmmakers to produce accurate representations of the dinosaurs.

DAVID LYNCH
David Lynch was born on January 20, 1946 in Missoula, MT. He is a film and television director and writer best known for his dreamlike storylines and uniquely offbeat characters. Some of his works include the TV series *Twin Peaks* and films such as *Dune*, *Blue Velvet*, and *Lost Highway*. Lynch also travels the country teaching and speaking on the topic of transcendental meditation; he advocates for its use in schools.

BILL GATES
Born on October 28, 1955
in Seattle, WA, Bill Gates is
best known as the business
mogul behind Microsoft, one
of the largest companies in
the world. He also founded
the Bill & Melinda Gates
Foundation, which holds the
intention of bettering the
global healthcare system,
reducing poverty worldwide,
and expanding education
and technology opportunities
for American students.

If I where president...

I would want to try } stop
Bulling. I want _everyone_ to be
treated equall, not to be told they
Don't 'fit in' Becase they Don't
Have Desiner shoses, or Because they
are tall or Short, fat or skinney. I
want everyone too feal wanted, }
neaded.

Hopefully a preisdent Someday,

Hazelynne

AMERICA TAUGHT ME TO DREAM BIG FUTURE PRESIDENT

When I'm President
There will be Peace
in the Middle East

WASHINGTON

Pascaline, 12

JOHN ELWAY
John Elway was born in Port Angeles, WA on June 28, 1960. He is the famed former quarterback for the Denver Broncos football team, which he helped become the national champions in Super Bowl XXXII and XXXIII. Currently, he serves as the teams Executive Vice President of Football Operations.

ZIA MCCABE
Rock pianist Zia McCabe was born in Brush Prairie, WA on June 2, 1975. She also plays the bass guitar, the drums, and she deejays. McCabe is best known as the keyboardist for the band The Dandy Warhols.

If I were president I would make sure the billions of dollars the U.S. sends to Egypt goes not only the Muslim-Brother-Hood Regime but the people as well. For instance when my family was in Egypt I saw that the people were getting poorer and the military getting richer.

-Pascaline

KEITH CAMPBELL
Stunt man Keith Campbell
was born on April 26, 1962
in Boise, ID. He has per-
formed as a stunt double,
stunt coordinator, and
stunt performer in more
than 130 film and television
projects, including as stunt
double for Val Kilmer in
The Saint and stunt double
for Tom Cruise in *Mission:
Impossible*.

If I were President I
would keep our country
from fighting with other
countries

Jordan

I AM YOUR FUTURE PRESIDENT

Daisy, 10
On vacation from Washington

EZRA POUND
Born in Hailey, ID on October 30, 1885, Ezra Pound was an influential American poet who spent much of his life living overseas. He is credited with developing Imagism, an early modernist poetry form that drew on Chinese and Japanese styles of vivid description.

PICABO STREET
Picabo Street was born in Triumph, ID on April 3, 1971. She is an Olympic gold medalist skier. Additionally, in 1995, she won the World Cup title, which no American skier had ever done before; she then did so again a year later.

If I were president I would try my best to replant a lot of the trees that have been cut down and destroyed in the past.

Daisy

WYOMING

Albert, 5

On vacation from Minnesota

JERRY ANDRUS
Jerry Andrus was born in Sheridan, WY on January 28, 1918. He was a world-renowned, self-taught magician and illusionist who was particularly known for his sleight-of-hand tricks. The documentary *Andrus: The Man, The Mind and The Magic* tells the story of his life and work.

PETE WILLIAMS
Born in Casper, WY on February 28, 1952, Pete Williams is a journalist and news reporter. Currently, he is an NBC news television correspondent, and he is also the former Assistant Secretary of Defense for Public Affairs.

ALBEhT

I WILL INSPIRE
THE NATION
FUTURE PRESIDENT

SCOTT AVETT
Born in Cheyenne, WY on
June 19, 1976, Scott Avett
is a singer and multi-instru-
mentalist who often plays
the banjo on stage with his
group, The Avett Brothers.
Their album *The Second
Gleam* hit the top ten
on the Billboard Charts
for Independent Albums.
Avett is also an accomplished
artist and printmaker.

If I were president
I would makemore
animal reserves
so animals don't
get hunt or ran
over!!

Gavin

Aspen, 7
On vacation from Texas

ANNE GORSUCH
BURFORD
Anne Gorsuch Burford
was born in Casper, WY
on April 21, 1942. She
was an attorney who
most notably became the
first woman to serve
as Administrator for the
Environmental Protection
Agency (EPA).

PATRICIA MACLACHLAN
Author Patricia
MacLachlan was born
in Cheyenne, WY on
March 3, 1938. Her
children's story, *Sarah,
Plain and Tall*, is known
and loved by many
young readers. The book
received a Newberry
Medal in 1986.

If I were presedent I would I would make the world helthy.

Aspen

UTAH

Payton, 5
On vacation from Texas

WALLACE THURMAN
Wallace Thurman was
born in Salt Lake City,
UT on August 16, 1902.
He was a writer, editor,
and publisher and is
best known for his
literary contributions to
the Harlem Renaissance
movement, including his
novel *The Blacker the
Berry: A Novel of Negro
Life* and his Broadway
play, *Harlem*.

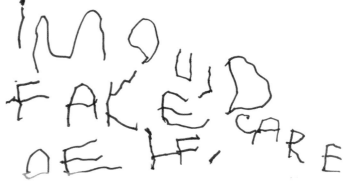

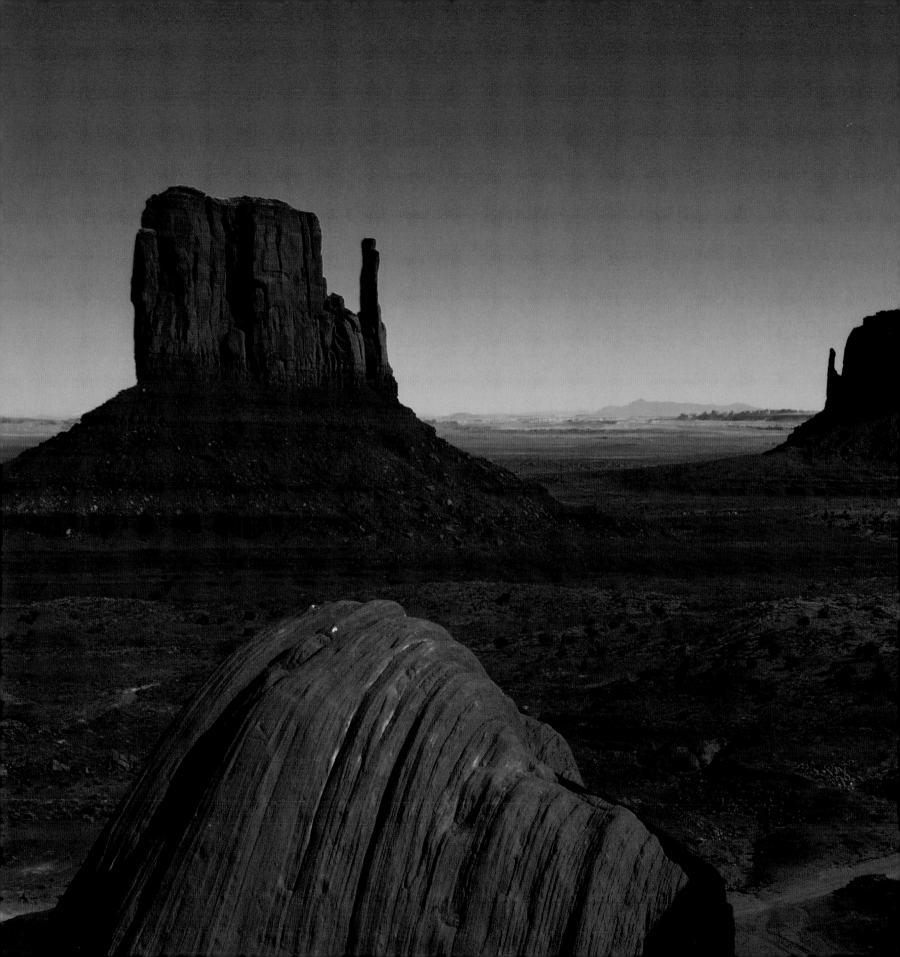

Ezra, 4
Micah, 2

NOLAN BUSHNELL
Born on February 5, 1943 in Clearfield, UT, Nolan Bushnell is the entrepreneur behind American staples Atari, Inc. and Chuck E. Cheese's Pizza-Time Theaters. His current project is called Brainrush, an educational software company. He is considered to be one of the founders of the video game industry.

ROSEANNE BARR
Comedienne and television star Roseanne Barr was born in Salt Lake City, UT on November 3, 1952. She won a Golden Globe for Best Actress as well as an Emmy for her starring role in the TV sitcom *Roseanne*. She once ran for President of the United States as a candidate under the California-originated Peace and Freedom Party.

I would give the homeless food and money!

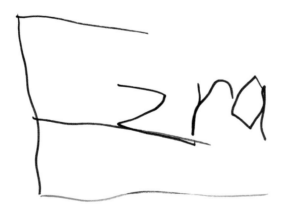

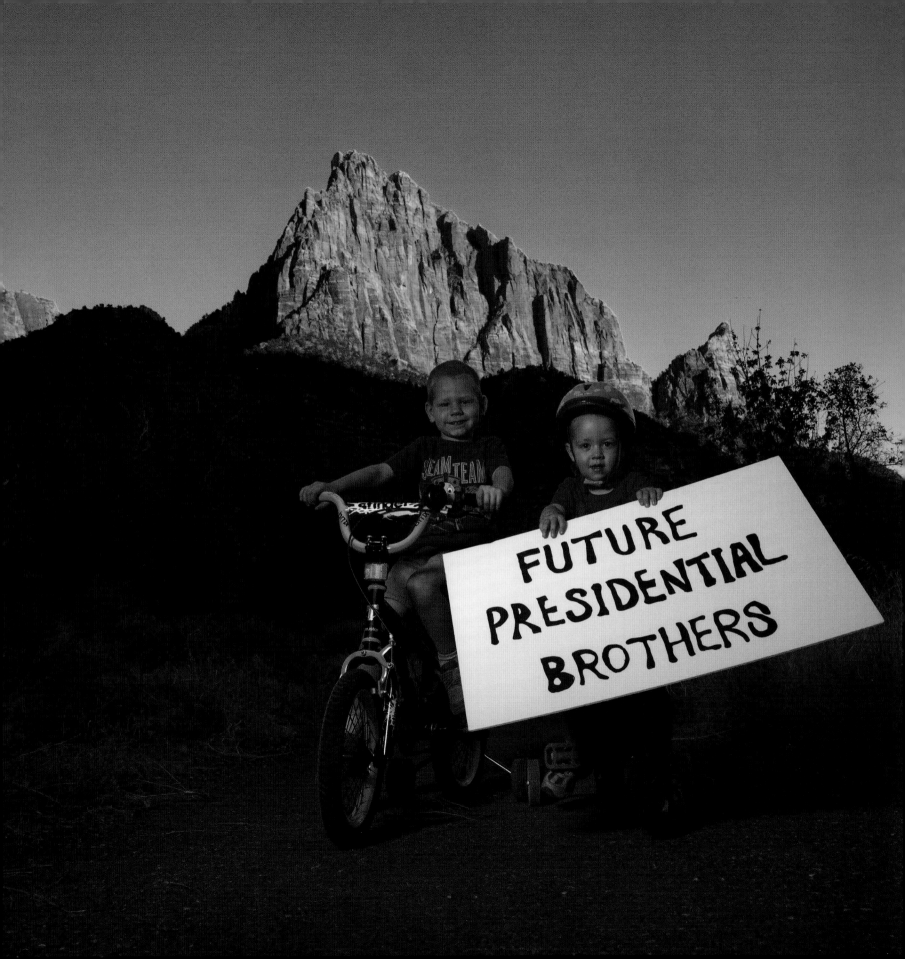

ELIZABETH WARREN
Born in Oklahoma City,
OK on June 22, 1949,
Elizabeth Warren is the
first female Senator of
Massachusetts and the
former Special Advisor
for the Consumer
Financial Protection
Bureau. Prior to
these roles, she was
a professor at Harvard
Law School.

IF I were president make it easyer to get a Job

Alex

Keep Peace Safe

Leighann

Juan, 9

JOHN HERRINGTON
John Herrington was born on September 14, 1958 in Wetumka, OK. He was the first enrolled member of a Native American tribe to travel to space. He honored his Chickasaw Nation heritage by bringing the tribe's flag with him on his space journey.

CHUCK NORRIS
Actor and martial arts expert Chuck Norris was born in Ryan, OK on March 10, 1940. He is perhaps best known for his starring role in the long-running television series *Walker, Texas Ranger*. He also founded his own school of martial arts, called Chun Kuk Do.

If I were President I would Put Storm Shelters in every School.

Juan

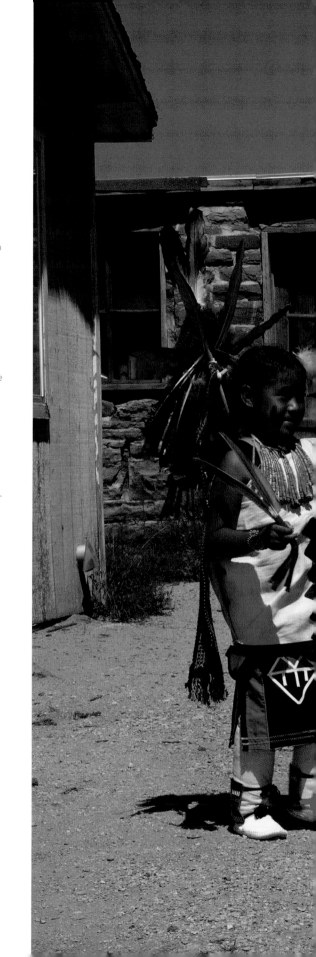

NEW MEXICO

Kingston, 8

WILLIAM HANNA
William Hanna was born on July 14, 1910 in Melrose, NM. He was a cartoonist and animator, voice over actor, director, and producer who co-founded the Hanna-Barbera television company. His best known animated programs include *The Flinstones*, *The Smurfs*, *The Jetsons*, and *Yogi Bear*.

NEIL PATRICK HARRIS
Film, television, and theater actor Neil Patrick Harris was born in Albuquerque, NM on June 15, 1973. His best-known works include starring roles in TV series *How I Met Your Mother* and *Doogie Howser, M.D.*, as well as in instant cult-classic musical *Dr. Horrible's Sing-Along Blog*. In 2014, he won a Tony Award for Best Actor in a Musical for his title role in the Broadway production of *Hedwig and the Angry Inch*.

If I was a PRESIDENt I would stop the war.

Kingston

WHEN I BECOME PRESIDENT
I WILL CLING TO
UNCHANGING PRINCIPLES

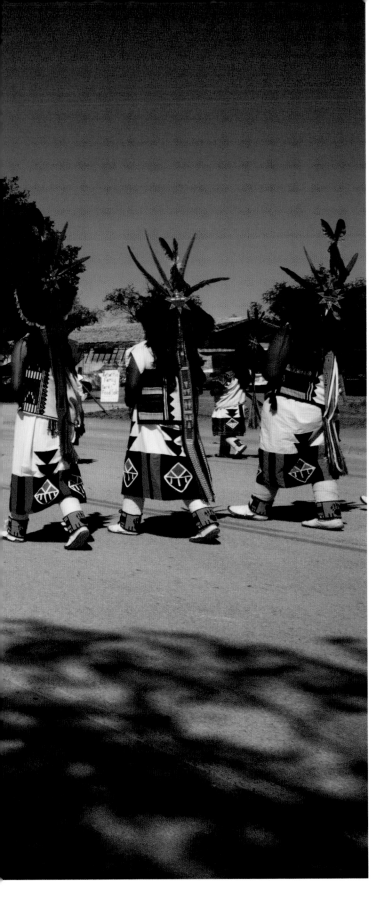

NEW MEXICO

Dazlyn, 10

DOLORES HUERTA
Born in Dawson, NM on April 10, 1930, Dolores Huerta is a civil rights champion who co-founded the National Farmworkers Association (later renamed United Farm Workers). Among the many honors bestowed upon her for her humanitarian work, she was presented with the United States Presidential Eleanor Roosevelt Award for Human Rights as well as the Presidential Medal of Freedom.

If I was president I would help my tribes Have a better life and everybody in the world. And Peace in the world

Dazlyn

FUTURE FATHER OF
A UNITED STATES
PRESIDENT

ARIZONA

Jake, 11
On vacation from New Mexico

LOUIE ESPINOZA
Louie Espinoza was born in Winkelman, AZ on May 12, 1962. He is a Featherweight division boxer who won the World Boxing Association Super Bantamweight Title in 1987. This achievement made him the first Arizona boxer ever to win the world championship.

LYNDA CARTER
Born in Phoenix, AZ on July 24, 1951, Lynda Carter is an actress best known for her portrayal of *Wonder Woman* on the television series of the same name. Prior to that, she won the Miss World USA beauty competition representing the state of Arizona. She is also an advocate for LGBT rights and finding a cure for breast cancer.

For the future I would like better schools, more jobs, a cleaner world and good clean outdoor places.

Jake

Desiree, *8*

JOAN GANZ COONEY
Joan Ganz Cooney was born on November 30, 1929 in Phoenix, AZ. She co-founded the Children's Television Network and helped to create and launch perhaps the network's most famous program, *Sesame Street*.

CESAR CHAVEZ
Born on March 31, 1927 in Yuma, AZ, Cesar Chavez championed the rights of farmworkers alongside Dolores Huerta, with whom he co-founded the National Farmworkers Association (which later became United Farm Workers). He organized effective non-violent protests and became a hero to laborers through his dedicated work on their behalf.

MY name IS
DESIRee

I want to be the next
PRESIDENT of the UNITED
States of America.
Lukachukai, AS.

R.C. GORMAN
Navajo artist R.C. Gorman
was born on July 26, 1931
in Chinle, AZ. He worked
in many artistic mediums,
including sculpture and
ceramics, with his paint-
ings being his best-known
works. *The New York Times*
called him, "the Picasso
of American Indian art."

I would help the community. help the poor. have everyone come together like a famle.

Zyler

CHARLES MINGUS
Born in Nogales, AZ on
April 22, 1922, Charles
Mingus revolutionized
jazz music with his
unique style that blended
traditional jazz with
new forms of his own
creation. He played the
upright bass, piano, cello,
and trombone.

If we were president we would try to make the world come together and stop the wars.

Lee
Zach
Steve

FIRST NATIVE AMERICAN
UNITED STATES PRESIDENT

ARIZONA

Martao, 5
Mariah, 2
Marcell, 4

STEVIE NICKS
Stevie Nicks was born
in Phoenix, AZ on
May 26, 1948. She is a
singer and songwriter
known for her role
as the Fleetwood
Mac front woman
for many years as
well as for her own
solo work. She was
voted one of the 100
Greatest Singers of All
Time by *Rolling Stone*
magazine.

If I were president I would help people around the world.

Martao

ALASKA

Maya, 10
Lea, 7

BENNY BENSON
Benny Benson was born
in Chignik, AK on October
12, 1913. At thirteen years
old, he entered a contest to
design the flag for the Alaska
Territory and won. When
Alaska was given statehood,
Benson's flag became the
official state flag.

If I was president I
would help homeless
people. I would make
sure they had a chance
to be anything they want.
I want everyone to have
a fair chance in Life.

maya

If I was
the president
I would
help the less
fortunate and
provide
with them
more
opportunities.

Lea

RAISED TO FLY HIGH

FUTURE MADAME PRESIDENTS

ALASKA

Grace, 8

JESSICA MOORE
Born in Palmer, AK on July 9, 1982, Jessica Moore is a professional basketball player. She played on the USA Women's U19 team in the U19 World Championship and helped bring home a bronze medal for the team.

ELIZABETH PERATROVICH
Alaskan native civil rights leader Elizabeth Peratrovich was born in Petersburg, AK on July 4, 1911. As a member of the Tlingit Nation, she testified on behalf of her people in support of the Anti-Discrimination Act, which provided equal rights for Alaskan natives.

If I was the president I would mack the world a better place making bad thing go away.

Grace

HAWAII

Jaden, 9
Ashton, 8

TIA CARRERE
Actress Tia Carrere was born on January 2, 1967 in Honolulu, HI. Of her many television, film, and voice-over roles, she is perhaps best known for her co-starring performance in the *Wayne's World* films.

DUKE KAHANAMOKU
Born August 24, 1890 in Honolulu, HI, Duke Kahanamoku was an Olympic medalist swimmer who brought home five medals for the United States. He is also credited with popularizing surfing on the U.S. mainland, as it was previously only known in Hawaii.

If I were president I would help the endangered animals.

Ashton

If I were president I would give the homeless homes and Kids with out food I would give them food

Jaden

BARACK OBAMA
On August 4, 1961 in Honolulu, HI, Barack Obama, the 44th President of the United States, was born. He is the first African-American ever to hold the office of the President, as well as the first Hawaiian-born President.

If our baby becomes President we would like to see an established unity of the character, soul, and mind of all humans.

James

MY STATE

MY NAME & AGE

NOTABLE AMERICANS
BORN IN MY STATE

IF I WERE PRESIDENT:

2016 / 2020 / 2024 / 2028 / 2032 / 2036 / 2040 / 2044 / 2048 / 2052 / 2056 / 2060 / 2064 / 2068 / 2072 / 2076 / 2080 / 2084 / 2088 / 2092 / 2096 /

ELECTED PRESIDENTS
OF THE UNITED STATES